DRAWING
OPTICAL ILLUSIONS

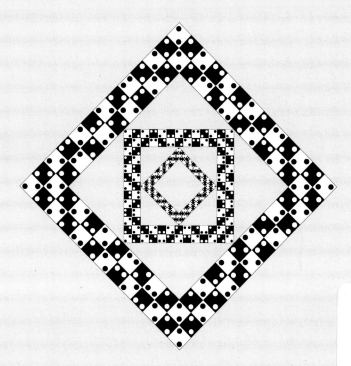

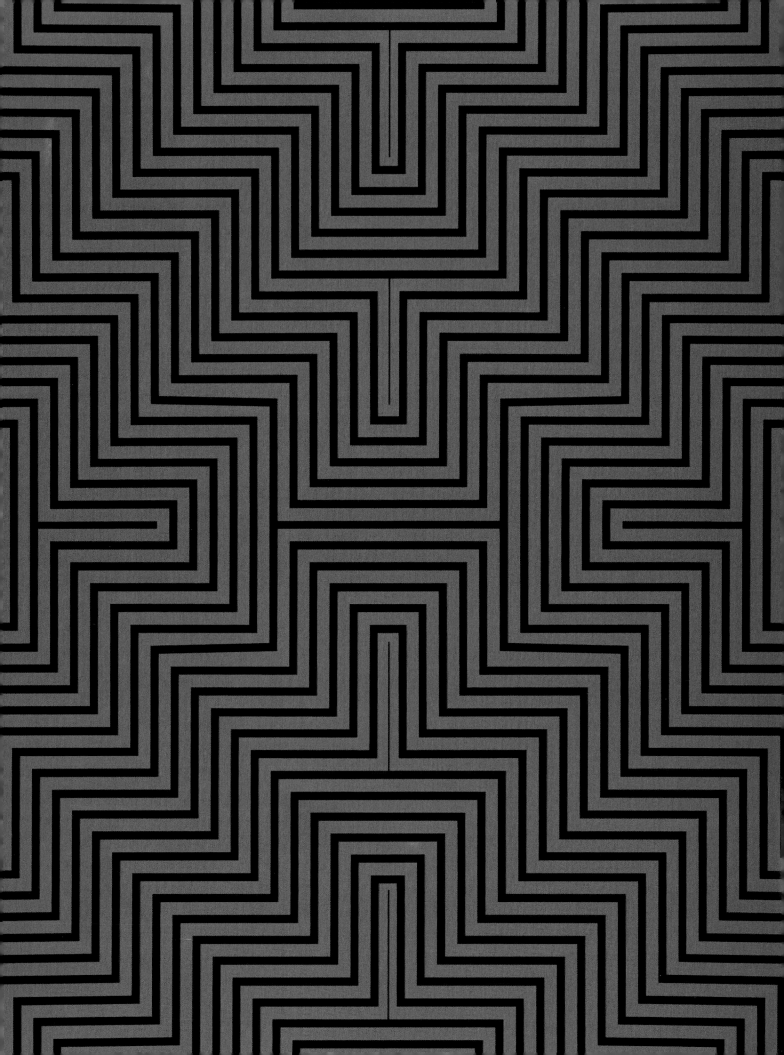

DRAWING
OPTICAL ILLUSIONS

CREATE YOUR OWN STUNNING ARTWORKS

Gianni A. Sarcone and Marie-Jo Waeber

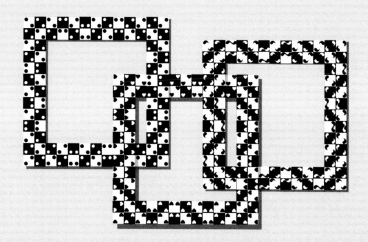

ARCTURUS

Dedication from Gianni A. Sarcone

To my uncle Vittorio Troïsi, my favourite gentleman farmer and adventurer who made me realize how colourful, flavoursome and creative Nature is!

ARCTURUS

This edition published in 2011 by Arcturus Publishing Limited
26/27 Bickels Yard, 151–153 Bermondsey Street,
London SE1 3HA

Copyright © 2011 Arcturus Publishing Limited/Gianni A. Sarcone &
Marie-Jo Waeber

ISBN: 978-1-84837-820-9
AD001713EN

Printed in China

CONTENTS

INTRODUCTION

*'Reality is merely an illusion,
although a very persistent one.'*

Albert Einstein

For centuries, visual or optical illusions have been created by means of the ingenuity of the human brain and they have exerted an enduring fascination on the viewer. Since the arrival of the printing press and, later, film and digital imagery, millions of illusions have been produced in the name of art, science, education and, especially in the modern world, entertainment.

Creating a new optical illusion, or even reproducing one that already exists, may constitute a real challenge for your artistic skills, or it may simply represent an original and funny way to express your creativity. With the aid of this book and a little patience, you will be able to draw effective and powerful optical illusions in a reasonable amount of time. The book is not intended to serve as a substitute for an art class; you will need a basic knowledge of fine arts to enjoy it, but the visuals are easy to follow and you can use your preferred art medium or technique to achieve your desired optical effect.

The book contains a collection of recent and ancient optical illusion effects, along with demonstrations and tips to inspire you to create your own work. The different optical illusions are organized by effects and applications, such as moving patterns, impossible or ambiguous figures, colour effects and distortion effects, presented in a way that will make it easy for you to put them into practice.

The emphasis of the book is on geometric and abstract imagery and on encouraging your own experimentation and discovery: using the examples in the book as a graphic resource, you may compare and combine them to create your own optical illusion compositions. The main purpose, of course, is to prompt you to exercise your most valuable resource – your creativity.

What are optical illusions?

Optical illusion is a particular style of art that plays tricks on our eyes and consequently baffles our perception. You might almost put the effect down to faulty vision, and in fact these visual tricks are sometimes used to assess the performance of the eye or the brain.

While what you see obviously depends on your eyes, it is the job of the brain to make sense of that information. Via the optic nerves, the brain receives electrical signals from the eyes which are thereafter converted into the sense of sight. Yet the brain adds some extra ingredients to the received image, such as attention, memory and meaning. We actually 'see' by comparing images from the outside world with the models inscribed in our memory. Each new object or visual experience will be encoded in our memory and will subsequently modify the way we perceive things. Sometimes memory

clashes with perception, when the stored model and the perceived image seem both coherent and incompatible, conveying double or contradictory meanings to the brain. At other times, the nature of our visual system itself causes visual interferences, such as seeing an object as blurred or vibrating. Whichever may be the case, when your brain gets it wrong, the result is an optical illusion.

The brain is a kind of device with known performances, whose internal workings are not completely understood but can be viewed in terms of outputs in relation to inputs. Since the Renaissance, scientists have been studying optical illusions to better understand how the brain interprets information (input data) and builds a representation of the surrounding world (output data). Meanwhile, architects, fine artists and designers have all regularly made practical use of optical illusions to aesthetically enhance the appearance of their creations, because real things often appear deceptive and 'discordant'. The idea, of course, is to produce a pleasant sensory quality in the building, painting or object, or sometimes to impress the viewer by creating objects in space that seem larger or smaller than they really are.

To joke and play tricks is a feature of our human nature, and some artists create optical illusions in their artworks as an intellectual game – but also as a challenge, because the means to create visual illusions have always been of a scientific or technical nature: illusive perspective, visual distortions or even visual ambiguities could never be created without an understanding of what lies behind them. In fact, most optical illusions were first discovered by artists and designers who produced textures and patterns while working within the wide range of the creative arts and crafts, long before they were rediscovered and 'officially' described by scientists.

Making optical illusions

The French painter Edgar Degas once said that art is not what you see, but what you make others see. Yet if any artwork is in itself already an illusion, then visual illusion pictures represent an art style that plays a game with our perception twice over. The illusionist artist has first to persuade the viewer that his or her depiction is real, though what the viewer sees is not the reality but a two-dimensional representation of it, made with the help of visual conventions and rules. At the very moment the viewer is going to be convinced, he or she falls into the perceptual trap of the second illusion, the real one created by the illusionist artist, plunging him or her into a state of cognitive hesitation and surprise.

Humans are curious by nature: they expect to be surprised and deceived, and indeed there is a Latin aphorism that asserts 'Populus vult decipi, ergo decipiatur', which means 'The people wish to be deceived, so let them be deceived.' Visual illusions are a kind of mental diversion – they capture the attention and are intriguing, challenging and fun as well. In other words, optical illusions force us to pause and question the nature of reality.

What you will need

The materials and equipment required to create optic patterns and illusive visual effects depends first upon your own ability: with a good ruler, a pair of compasses, pencils, coloured pens and some patience you should be able to reproduce all the examples in this book without too much difficulty. Some will involve tracing images in order to duplicate them, for which you can use tracing paper or a lightbox. Naturally, you can also use your favourite drawing software program or other modern devices such as a scanner or photocopier to help you achieve the best visual effect. But do not expect to create a masterpiece at the first attempt – it is very important to do as many freehand sketches as possible before you start the final realization of your optical illusion picture.

Try different mediums to add colour to your final sketches, such as ink, watercolour, gouache, oil, acrylic, crayon, charcoal, pastel, colour pencil, marker, collage, or sumi-e (oriental ink and wash). Mixed media often produces interesting visual results, but what counts is to use what you are most at ease with. When putting the finishing touches on your artwork, do not try to achieve perfection – many novices strive for excellence but perfection is unattainable, as Salvador Dalí pointed out: 'Have no fear of perfection, you'll never reach it!'

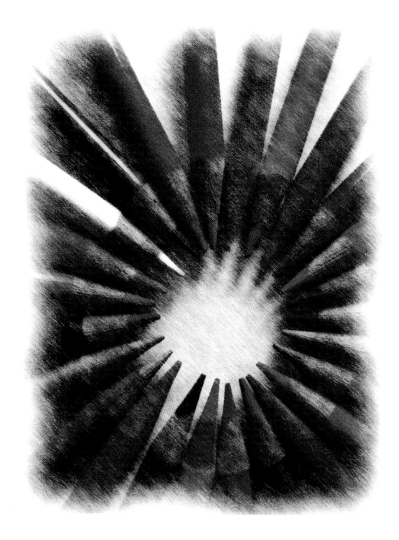

'To accomplish great things, we must not only act, but also dream; not only plan, but also believe,' said the French poet Anatole France, and with this message of encouragement to spur you on, I hope you will enjoy the challenges offered by this book.

Gianni A. Sarcone
Designer and researcher in the field of visual perception

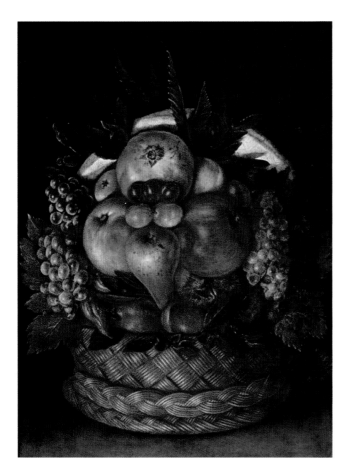

Here is a famous example of a reversible and ambiguous optical illusion created by the Italian artist of the Renaissance, Giuseppe Arcimboldo (1527–93).

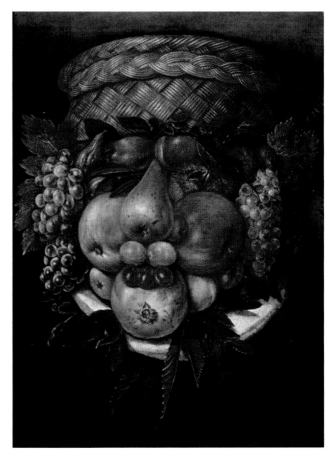

OPTICAL ILLUSIONS USING LINES

The German painter Paul Klee once said, 'A line is a dot that went for a walk', and he was largely right! Two distant points can always be joined together by a straight line, and in fact it was by connecting prominent stars of the welkin with an imaginary line that early man created the first representation of the constellations.

In the rigorous world of mathematics, a line is a straight or curved continuous extent of length without breadth. In art, however, it is the fundamental element without which nothing can be outlined or represented: it is the essential surge that flows from the artist's hand.

A line can be cut into segments. With two small segments it is possible to create simple but essential figures such as L, V, T and X. In optical illusions too, lines and segments are important, and especially the oblique segments and those particular combinations of segments called crosses and chevrons (also known as herringbones).

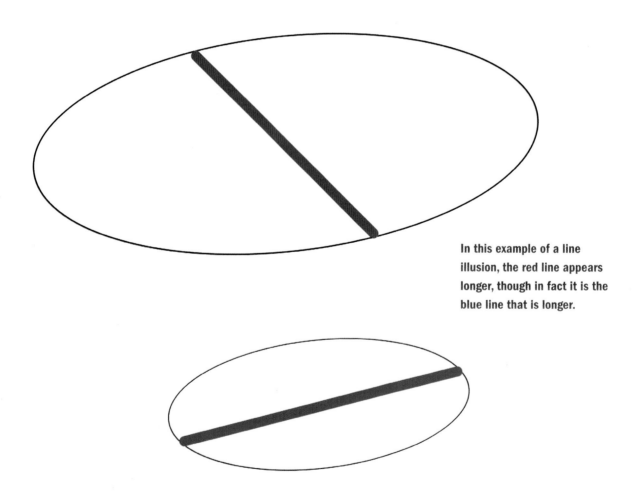

In this example of a line illusion, the red line appears longer, though in fact it is the blue line that is longer.

The Müller-Lyer Illusion

1

This is the simplest illusion ever. Just draw two lines of equal length (Fig. 1). At each end of one line place two segments in the shape of a right-angled V pointing outwards; at each end of the second place an identical V shape, but this time pointing inwards. Now the second line looks much longer than the first (Fig. 2), though they are the same length. The V-shaped segments or chevrons are present in many optical illusions, as you will discover in the following pages.

2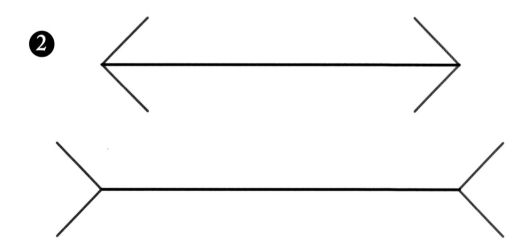

Parallel or Diverging?

In 1860, the German astrophysicist Johann Karl Zöllner noticed that in a herringbone pattern designed for a dress fabric the parallel lines appeared to be divergent and wrote an article on this optical illusion. The classic Zöllner illusion traditionally represents a series of oblique parallel lines intersected by transversals (see facing page).

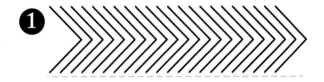

Fig. 1 shows a set of chevrons, pointing to the right and all exactly aligned and parallel. In a herringbone pattern, the adjoining row of chevrons points in the opposite direction (Fig. 2a). The more acute the angle of the chevrons, the stronger the illusion will be (Fig. 2b).

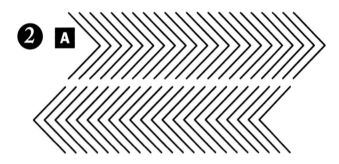

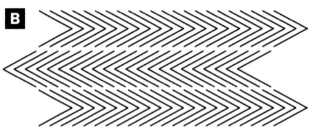

In Fig. 3a (and its negative picture in Fig. 3b) you can see that the alignments of chevrons within the pattern appear to converge towards and diverge away from each other.

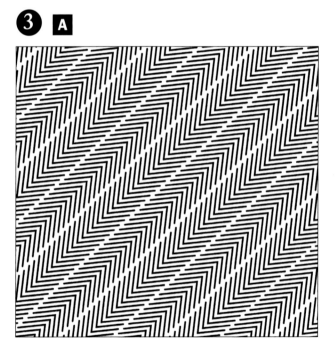

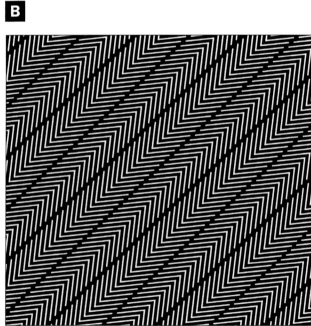

The Classic Zöllner Illusion

❶ 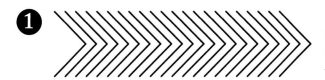 If we trace parallel lines on the herringbone alignments, as shown here in Fig. 2a, we obtain the classic Zöllner illusion (Fig. 3a) and incidentally increase the virtual tilting effect of the pattern.

❷ **A** 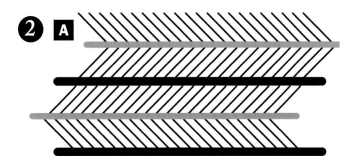 **B**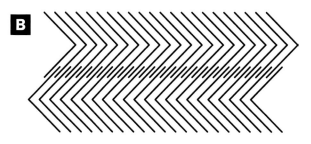

In Fig. 3a the lines seem not to be parallel, though they are in reality perfectly so. This is because the brain misinterprets a series of straight lines in contrast to other regular lines that are perceived as background elements. In fact, every array of short oblique segments (Fig. 2b) is interpreted by our brain as a whole seamless oblique line leaning in the direction of the segments. If a transversal line is traced on this array of parallel oblique segments, the brain 'overcorrects' the tilting impression of the pattern in the background and, in doing that, it unintentionally makes the straight line in the foreground appear to slant in the opposite direction to the leaning segments. We can compare this to another everyday phenomenon: when you stand in a vehicle such as a train, your body tends to oppose the direction of the motion. This balancing effect is a natural reflex.

❸ **A** 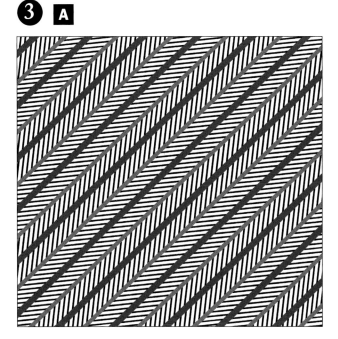 **B**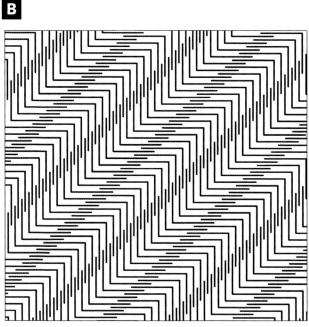

Vibrating Diamonds

Using chevron-like elements, you can build an intriguing pattern that vibrates and flickers. Simply draw an alignment of chevron-like elements, as shown in Fig. 1 (note that the two strokes of every V-shaped element join at 90 degrees). Then reproduce those chevron alignments, one upon the other (Fig. 2), to create a whole seamless pattern. Embed the arranged sets of chevrons into a square frame (Fig. 3a). By rotation and reflection, you will obtain four different configurations from the same square cell (Fig. 3b). Finally, assemble the four cells together to obtain an amazing flickering pattern.

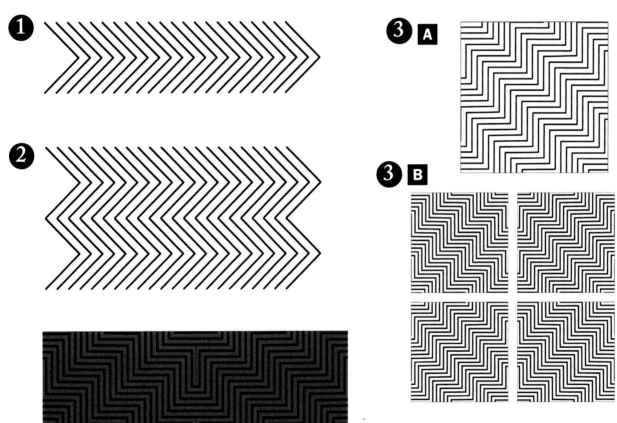

Look at the final result on the left – you will find it exhausting to hold your eye still! The perturbing optic effect arises because there are so many lines of contrasting orientation close together – the eye is unable to make small enough scans to identify the position of individual lines. Moreover, the lines seem to organize themselves into diamond-like frames that appear to advance or to recede.

Chevron Tiling

Drawing the cell or basic pattern element...

The cell (a) and the spatial distribution of the cells (b).

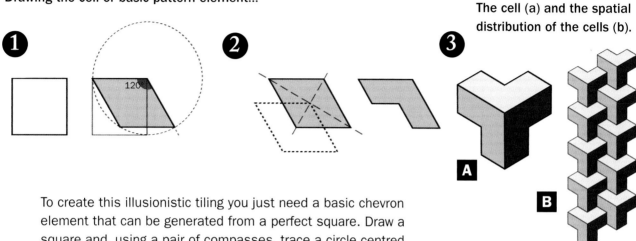

To create this illusionistic tiling you just need a basic chevron element that can be generated from a perfect square. Draw a square and, using a pair of compasses, trace a circle centred on a corner of this square, so that the perimeter touches two of its other corners. Now, with the help of a protractor, draw within the circle a rhombus with opposite sides angled at 120 degrees (Fig. 1). Crop out a portion from the rhombus, as shown in Fig. 2. Finally, by rotation of 120 degrees and reflection, you will obtain the cell shown in Fig. 3a.

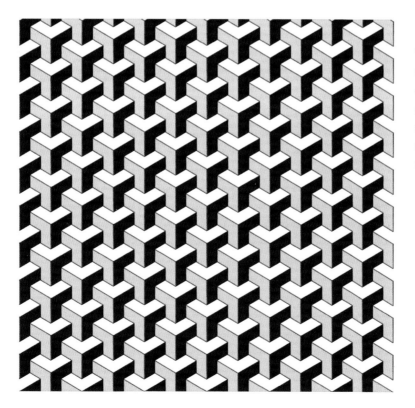

In the final picture you can see that by repeating the basic cell as shown in Fig. 3b, you will obtain a convex impossible structure formed by ambiguous cubes that become magically concave if you turn the picture upside-down.

Chevron Tiling Variant

If you crop out a small portion from the basic chevron as shown in Fig. 1 and join three of these chevron elements together you will obtain another simple cell (Fig. 2a) that, when assembled, forms an intriguing impossible net of parallel bars in oblique projection (Fig. 3).

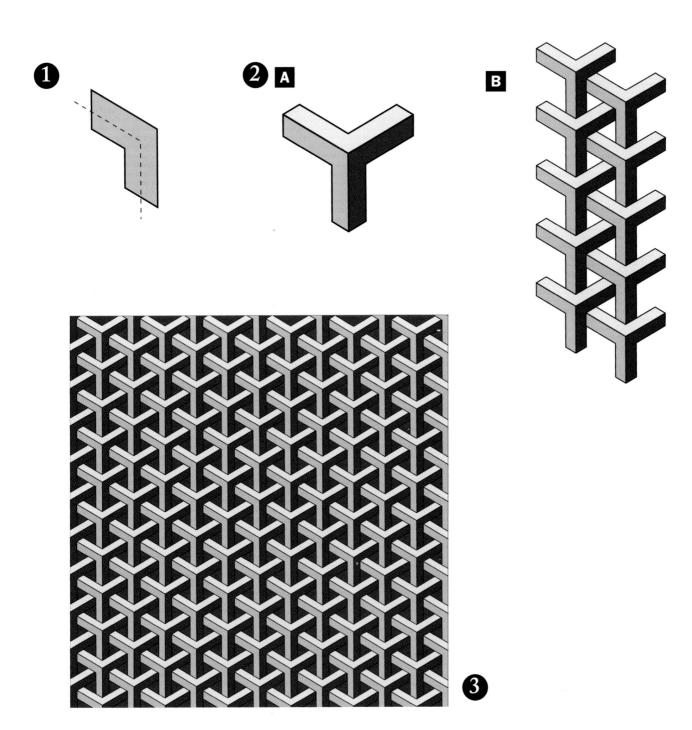

Pulsating Pattern

①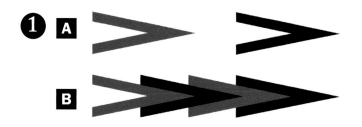

To create this simple but very effective pulsating pattern all that is needed is to stack chevrons of alternating colours together, as shown in Figs. 1a, 1b and 1c, and to display those arrays of chevrons radially around a circle (Fig. 2). If you stare at the centre of the picture, the rays of chevrons seem to radiate and, correspondingly, the background colour appears to slightly pulsate.

②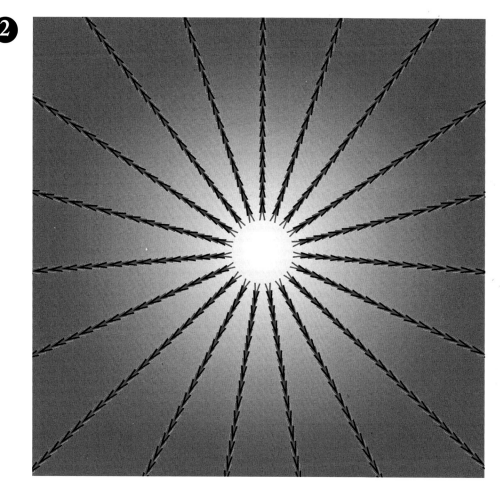

The choice of colours is fundamental to making this illusion work. One of the pair of chevrons should always be black. If possible, select a solid background colour with a simple and smooth radial gradient.

In this variant the colours of the chevrons and the background have been swapped.

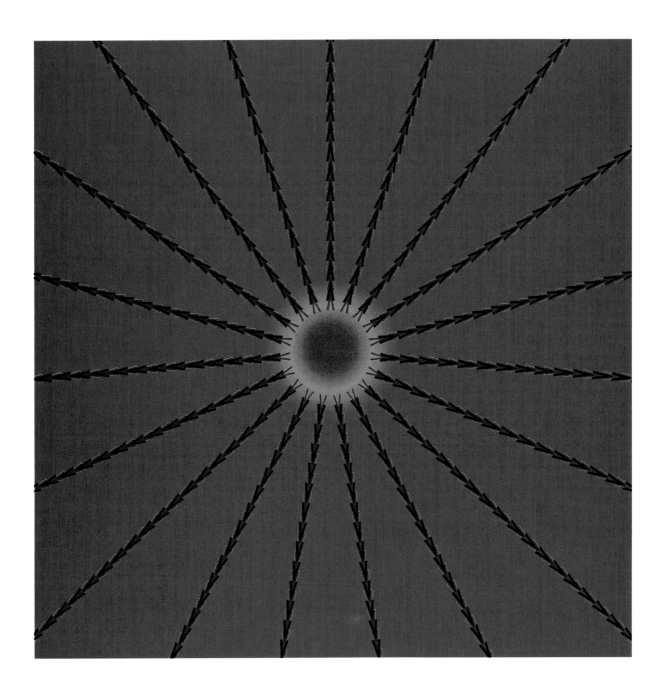

Leaning Effects

Straight lines made with collinear segments painted in alternating brightness or colours (Fig. 1) can produce interesting tilting effects within chequered patterns. Following the simple diagrams in Figs. 2a and 2b, fill a chequerboard with horizontal parallel lines and alternating colour segments: the finished pattern (Fig. 3) gives the overall feeling that the rows of squares alternately diverge and converge.

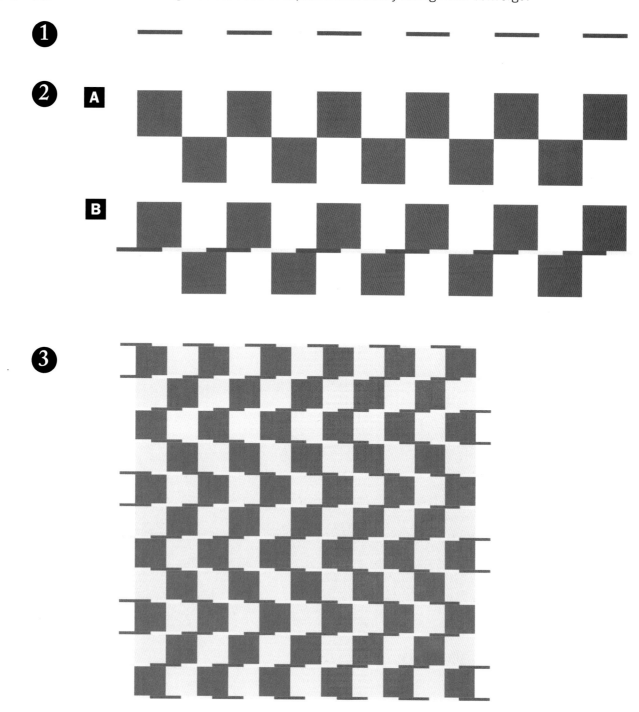

In the three examples shown here, you can see that the chequerboard has been filled horizontally and also vertically with the same segmented lines. In each case the pattern appears distorted, though in fact the rows and columns are perfectly straight and parallel to each other. Fig. 4 shows lines that appear to alternately converge and diverge; Fig. 5 appears to slant to the right, while Fig. 6 seems to lean slightly to the left.

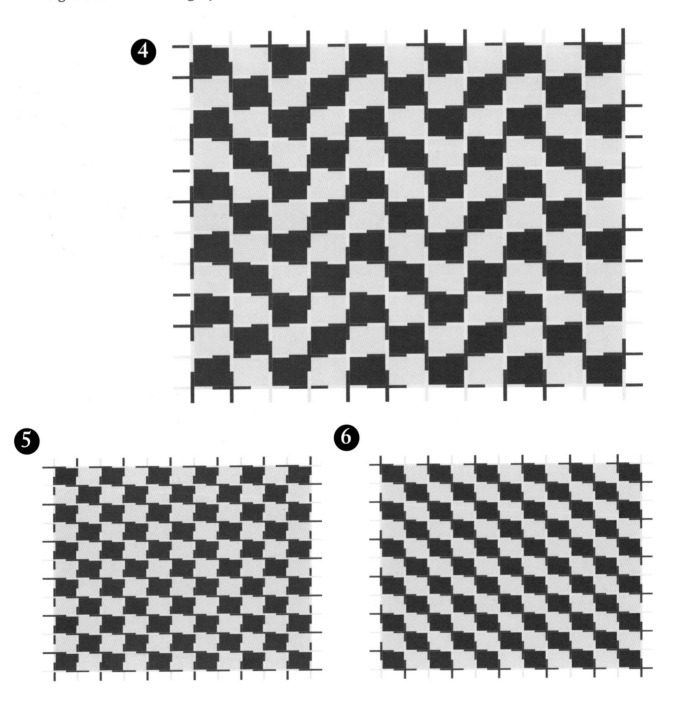

More Leaning Effects

1 **A**

B

Instead of segments you can use an alignment of small crosses with just two alternating tones or colours (Figs. 1a and 1b) to achieve the same tilting effect shown in the previous pages. In the two examples below, you can see that when small crosses of contrasting colours are placed at the corners of the squares, the chequerboard looks slanted or wavy.

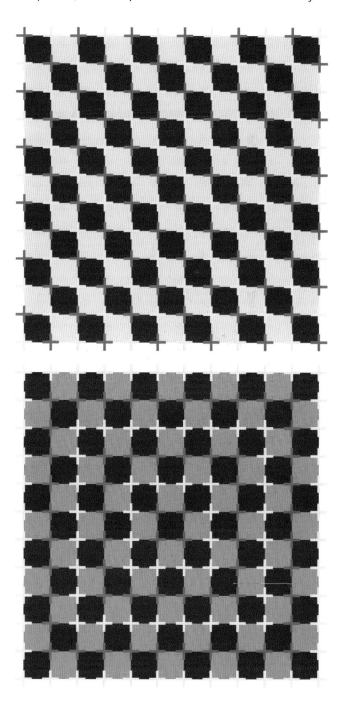

This type of striking illusion is related to the large family of 'twisted cord illusions': the lines seem to be bent one way or another, though they are perfectly straight and parallel to each other. The illusion of the twisted cord effect is probably due to orientation-sensitive simple cells in the striate cortex, which interact to combine closely spaced tilted lines into a single tilted line.

OPTICAL ILLUSIONS USING SQUARES

The square is a fundamental geometric shape and in a horizontal-vertical position is an expression of the two dimensions that constitute a surface. Symbolically, the square means *enclosure, land, field, ground*, or the element *earth*. The Egyptians used it originally as a pictorial sign for *stool of reed matting*. Squares have been used as basic pictorial elements by Suprematist and Neoplasticist artists – for example, *Black Square* by Kasimir Malevich and *Compositions* by Piet Mondrian respectively.

Size Distortion

This is the simplest example of illusory size distortion applied to squares. Draw two identical squares, rotate one of them by 45 degrees and then present them side by side, as shown here. Curiously enough, though they are the same size, the diagonally placed square looks much larger than the horizontal square.

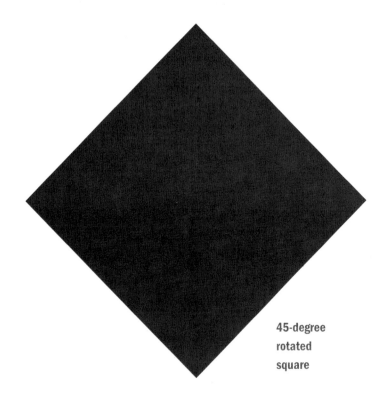

45-degree rotated square

Hidden Squares

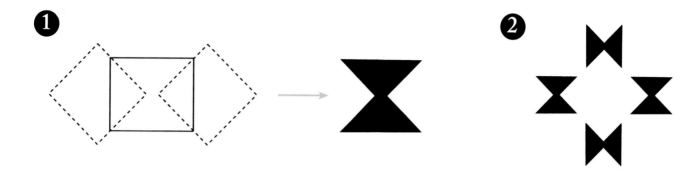

This optical illusion that can be done with squares is a bit more difficult. First, make the cell or basic pattern element by cropping out two right-angled pieces from a rectangle as shown in Fig. 1. The dimensions of the original rectangle are not important. Next, set the spatial distribution of the cells. Arrange groups of four cells so that they outline a virtual square (Fig. 2), and reproduce this arrangement to obtain a sufficiently large pattern.

There are 66 virtual squares in the diagram below, but in fact none of them is drawn. This effect is known as a subjective or illusory contour.

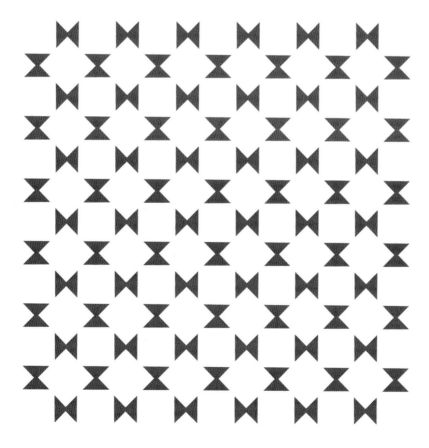

Ambiguous Depth

A wire-frame drawing of a cube in oblique perspective can be very perturbing because it does not contain any information about which part of the cube is in front and which is behind. Thus, it can be interpreted in at least two different ways: when you stare at the picture, it will often seem to flip back and forth between the two valid interpretations (this effect is called 'bistable perception'). This ambiguous illusion was named 'Necker's cube' in honour of the Swiss crystallographer Louis Albert Necker, who first described it.

❶

 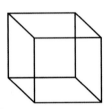 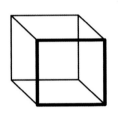

❷

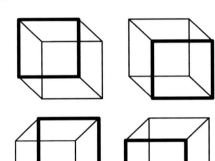

Draw a cube, following the stages shown in Fig 1. Emphasize the lines of one face of the cube. As shown in Fig. 2, rotating and reversing the cube offers a variety of ways in which it can be interpreted.

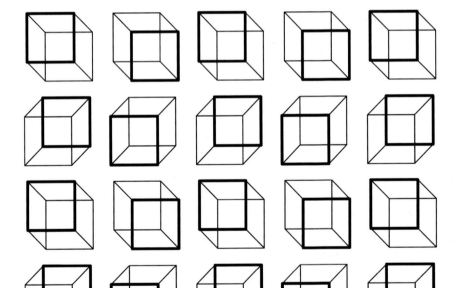

This diagram is an arrangement of all the possible interpretations of the same wire-frame cube. The more interpretations are shown, the more confusing the illusion is to the brain.

Wobbling Effect

To make the basic cell of the pattern below, simply draw a set of regular vertical stripes within a square (Fig. 1). Then draw a smaller square with corners touching the sides of the larger square (Fig. 2a), and invert the colour of the stripes (Fig. 2b).

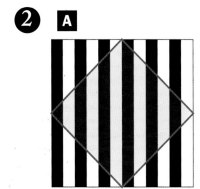

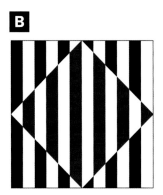

In a repeating pattern, the diagonally placed squares seem to have wobbly corners and to move slightly.

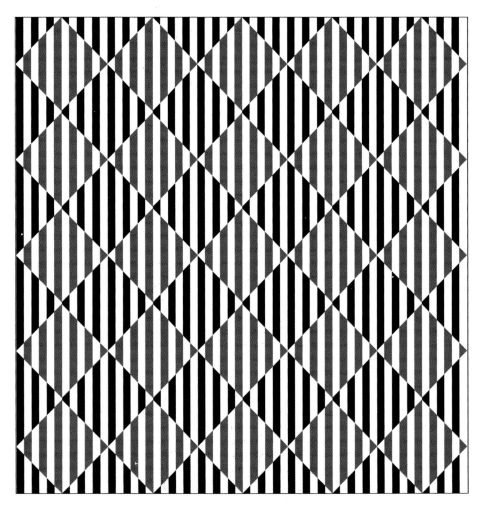

Bulging Effect

You can easily create this chequered bulging effect with the help of the Blend tool in Illustrator or Freehand, which allows you to blend one shape into another one. If you do not use either of these drawing software packages, you can sketch the basic model on graph paper.

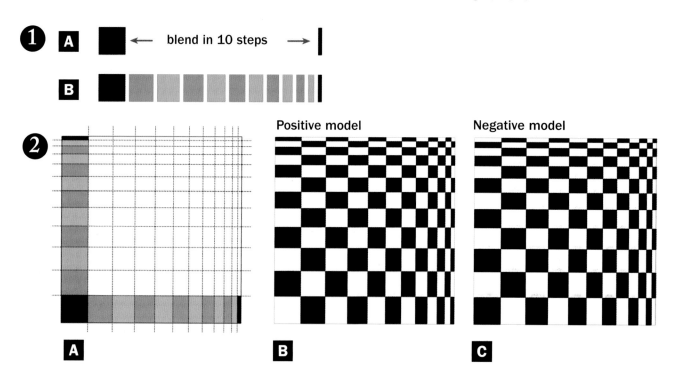

Blend a square into a thinner rectangle in 10 or 11 steps (Figs. 1a and 1b). Next, use the resulting rectangles as a guide to draw lines (logarithmic coordinates) within a square, as shown in Fig. 2a. Fill the vertical and horizontal lines outlined by the series of rectangles with alternating colours (Figs. 2b and 2c).

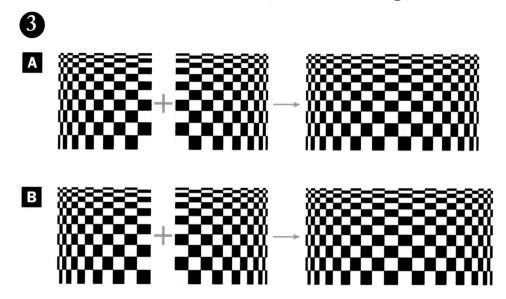

Next, combine your models together. In Fig. 3a, two mirrored positive models are combined together, whereas in Fig. 3b a positive model is joined to a negative model.

With the basic models assembled as shown in Figs. 3a and 3b, you can now create these complete patterns and experiment with other interesting designs.

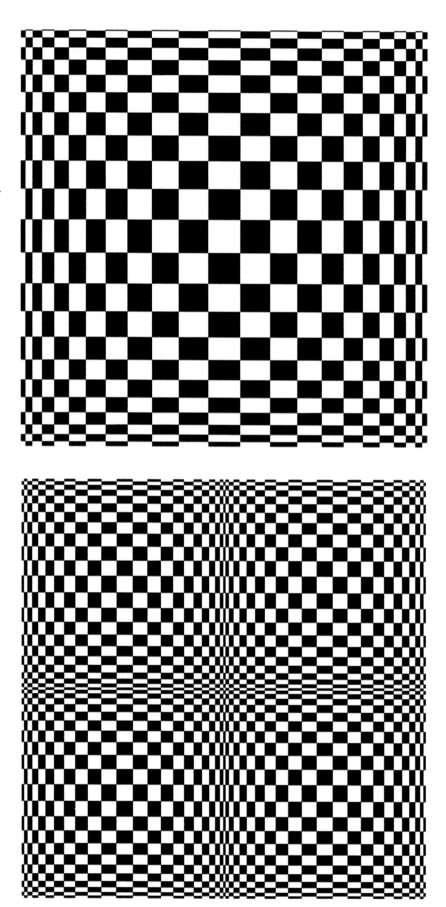

Tunnel Effect

Draw two diagonals through a square, then divide it with radial lines, spaced every 10 degrees, traced from the centre of the square (Fig. 1a). Draw another square that is approximately 5.5 times smaller in height than the first one (Fig. 1b). This is a diagonal reduction rate of 18 per cent (most scanners, photocopiers and vector drawing softwares such as Illustrator, Freehand and CorelDraw use diagonal reduction – for example, a 70 per cent reduction ratio on a photocopier is equivalent to half the original). Then make five copies of this small square, reducing each new square to 64 per cent of the previous one (if you do not use any drawing software, you can sketch this pattern on graph paper). Use these reduced squares as a guide (Fig. 2a) to draw the six inner square frames of the pattern (Fig. 2b).

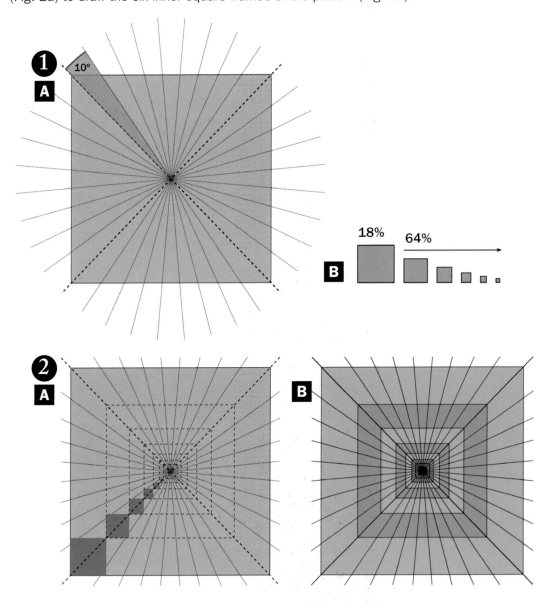

The radial lines and the sides of
the inner squares outline sets
of trapeziums that can be filled
with alternating colour or with
black and white, as shown in the
illustration below.

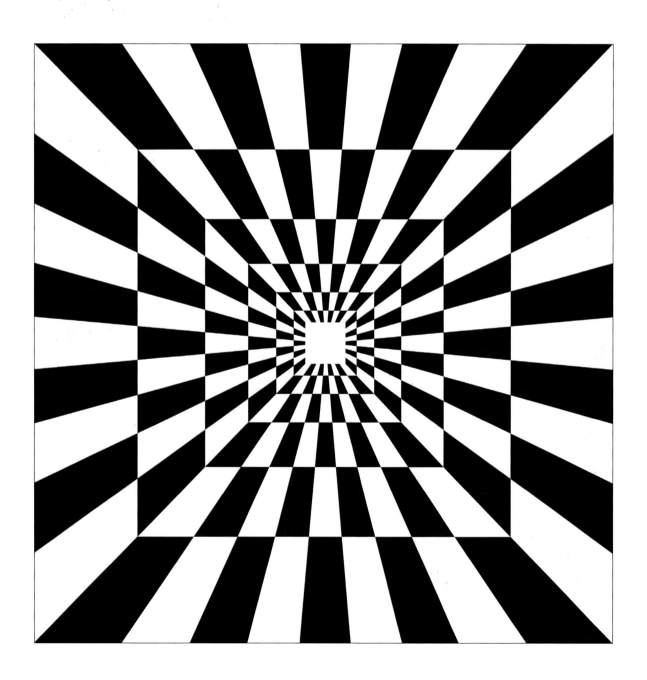

You can enhance the 3D tunnel
effect by adding blurred coloured
frames as in this design.

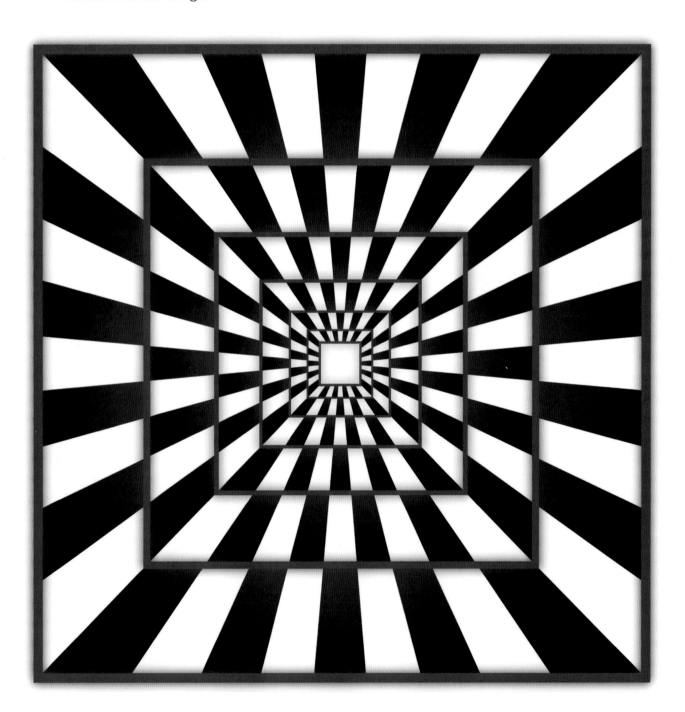

Tilting Effect

Tessellating patterns frequently appeared in the art of M. C. Escher, and can be seen throughout history from ancient architecture to modern art. A tessellation is a collection of elementary plane figures (flat, closed figures with straight or curved lines) or patterns that fill a surface with no overlaps and no gaps.

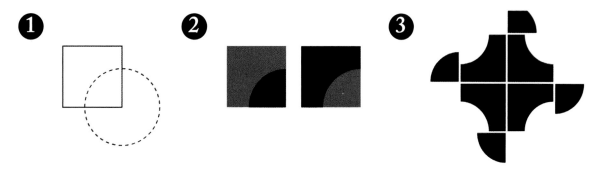

Make the tiles by drawing squares, then marking a semi-circle on each (Fig. 1). Colour the tiles using two colours, alternating which is the dominant one (Fig 2). Fig. 3 shows the spatial distribution of the tiles used to make the green and black tessellated pattern on the right. Tessellating patterns can also produce some interesting visual effects; though the horizontal and vertical orange lines appear to tilt, they are straight and perfectly parallel to each other. This pattern is inspired by the early American quilt pattern known as Solomon's Puzzle, or Drunkard's Path.

Distortion Effect

The way that the brain interprets what the eye sees depends upon context. Some interesting shape-distortion effects can be produced by the interaction between the actual shape of the object (in this case a square) arranged within a pattern and the shapes of nearby elements (the small contrasting discs).

Start with a square (Fig. 1) – the four blank circles show how to distribute the black discs or figurative elements within the square. On four separate squares, draw discs placed diagonally or aligned at the bottom (Fig. 2) and render them in two alternating colours. Assemble the squares of Fig. 2 in a double-row chequered arrangement (Fig. 3). Instead of small discs you can also use other motifs such as hearts or yin-yang symbols.

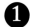

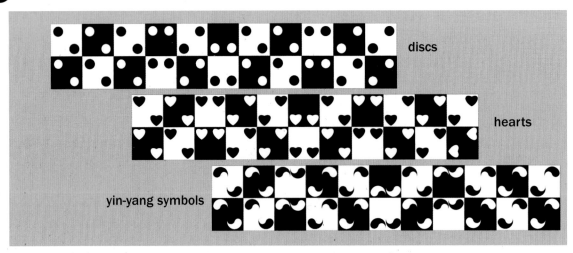

discs

hearts

yin-yang symbols

By assembling four similar double-row arrangements you can now make interesting chequered square frames (see right). If you have done it correctly, the square frames should look wavy even though they are perfectly straight.

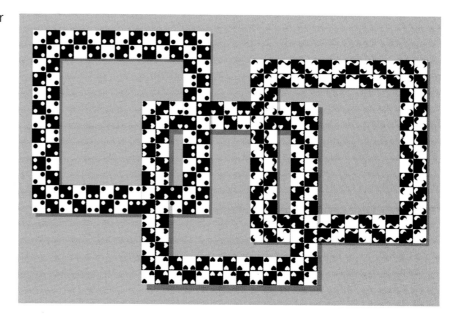

To enhance the wavy effect you can also distribute the two-colour tiles in order to form three concentric chequered square frames, as shown here on the right. Yes, everything is straight in this picture!

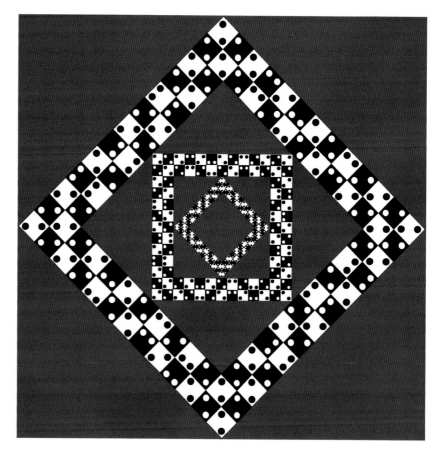

Shrinking Pattern

This illusion is made with three layers of patterns. The basic cell is not difficult to draw (Fig. 1), but the spatial tiling of the design requires precision (Fig. 2). The most difficult part is to draw the white and black shadows of the basic colour pattern (Fig. 3), but with a little perseverance you should be able to obtain good results.

1

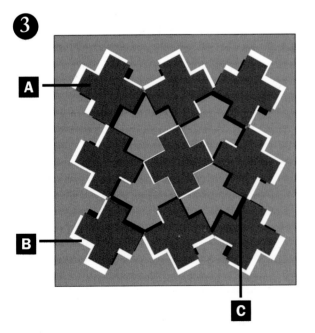

Start by joining four squares together, arranging them tightly in order to leave a central square as shown in Fig. 1. Then reproduce only the outer profile of this composition of squares to make the elementary tile you will use for the pattern. The spatial distribution of the tiles within the pattern should resemble the example shown in Fig. 2.

2

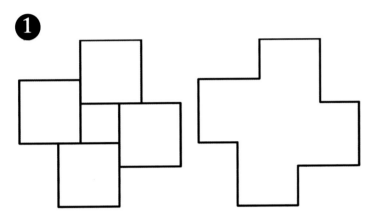

3

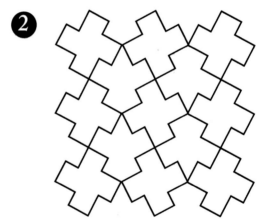

Fig. 3 shows the graphical layout of the tiles. The foreground layer A is the basic pattern. In the background layers, B is a copy in white of the basic pattern enlarged to approximately 105 per cent and C is a copy in black of the basic pattern reduced to approximately 95 per cent. The three different layers of tiles should then be centred one on another.

Move your eyes all over the tessellation below and you should see the tiles start to shrink or spin. The effect is enhanced if the colour of the background contrasts with the colour of the patterns. The relative motion effect is mainly due to the white and black shadows.

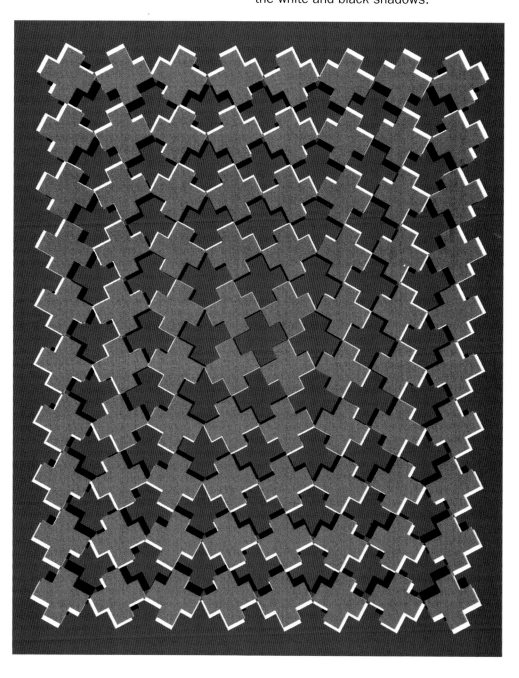

Hypnotic Spirals

This design is based on the 'pursuit curves' that would be formed if four dogs set off to chase each other from the corners of a square field. The path created by each dog is an equiangular spiral.

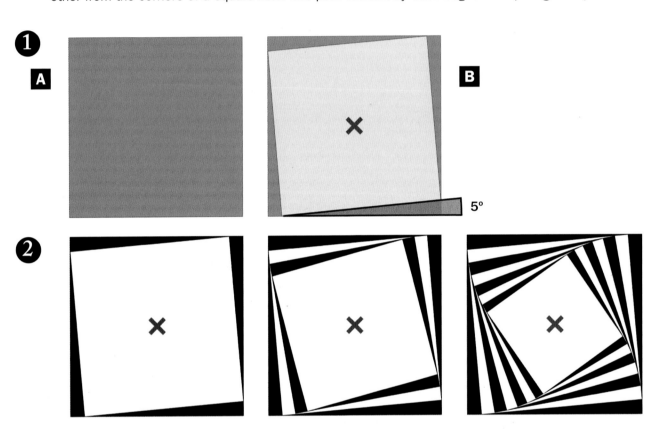

First draw a large square (Fig. 1a), then turn every following square 5 degrees around its centre (Fig. 1b) and compress it at the same time (reducing to approximately 96 per cent at each step), so that its four corners touch the sides of the preceding square (Fig. 2). As you add more squares, the corners form four hypnotic spiral arms. The resulting spiral belongs to the large family of the logarithmic spirals which appears in nature. Wonderful examples are found in shells, such as those of the nautilus and fossil ammonites, or even in spiders' webs.

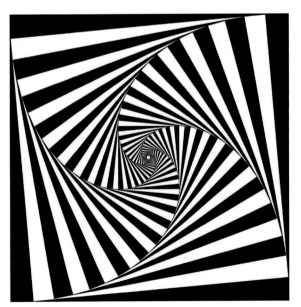

In the picture below, where the diminishing squares have been pushed to the limit, you will see that the arms of the spirals appear to move slightly.

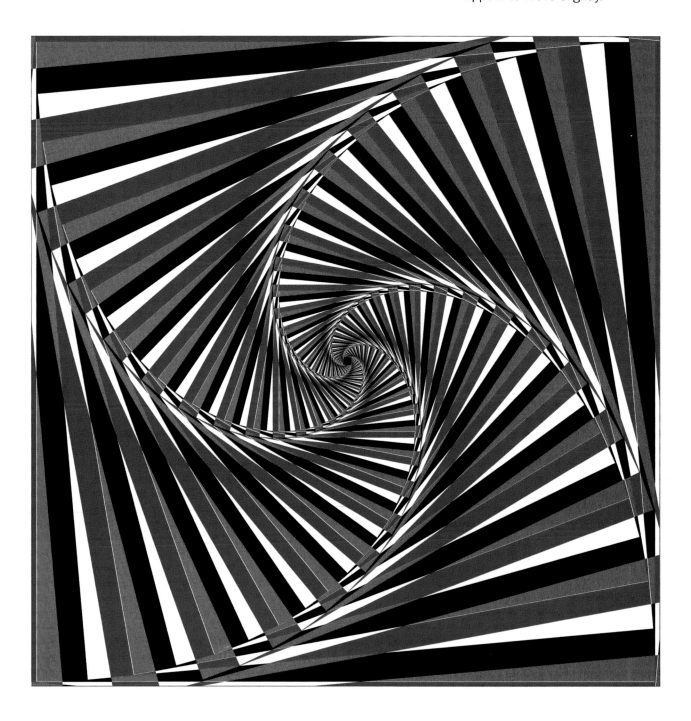

PARADOXICAL ILLUSIONS

Conjuring and optical illusions sometimes collide, and in this section we shall look at some remarkable geometric paradoxes, perception puzzles and visual conjuring tricks. You will discover how, with just a few manipulations, you can visually transform an object into another, making part of it disappear or apparently shrink – illusions known as 'vanish puzzles'.

There are two types of vanish puzzle – figurative and geometric. The former involve rearranging the parts of a puzzle representing a scene with a series of elements (people, animals and so on), so that once the rearrangement is completed an element of the scene disappears (or reappears). In geometric vanish puzzles, there is either the apparent disappearance of a portion of the puzzle or an apparent reducing of the area when the pieces of the puzzles are rearranged.

The first example of a vanishing area puzzle was discovered in the book *Libro d'Architettura Primo* by Sebastiano Serlio, an Italian architect of the Renaissance. As you can see in the reproduction here, Serlio transformed the same 3 x 10 rectangle (ABCD) into a 4 x 7 rectangle (yellow shape) and a 1 x 3 rectangle divided into two triangles (blue shapes). However, if we add together the yellow and blue areas we obtain 1 square unit more than the original rectangle ABCD: in fact, 28 + 3 = 30 + 1. Curiously, in converting one rectangle into another, Serlio did not notice that the two surfaces had different areas, and the first known documented book that describes vanish puzzles was *Nouvelles récréations physiques et mathématiques* by the French author Edme Gilles Guyot, published around 1770.

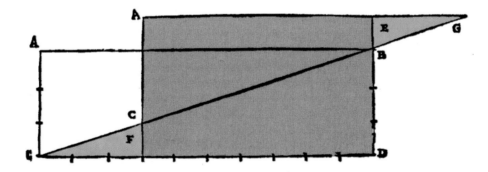

Because of their visual impact, vanish puzzles are really striking, but their mechanism is quite simple: the part that disappears is only redistributed differently on the remaining parts of the puzzle, and the magic is simply based on the visual persuasion that the puzzle is really different after manipulation.

The Appearing-disappearing Hole

Here you will discover how to make a kind of 'vanishing area paradox' puzzle. The final challenge will be to understand just how and why it works!

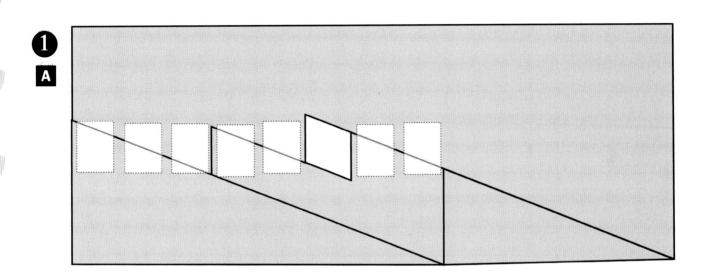

Reproduce the model in Fig. 1a, drawing on the black cutting lines as shown. Then draw simple shapes or subjects inside the seven rectangular boxes: in Fig. 1b there is an egg in each box. Cut the puzzle into four pieces, following the black lines. Cut out the blank diamond and discard it.

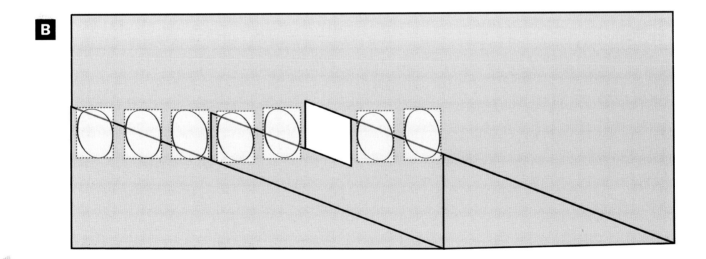

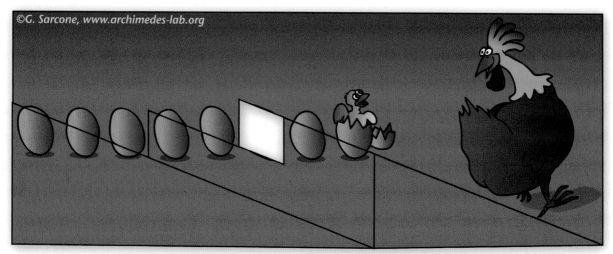

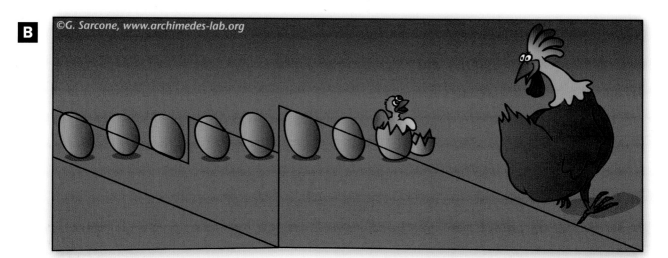

As you can see in Fig. 2a, there are exactly seven eggs. Now, if we rearrange the triangular pieces of the puzzle, an extra egg appears and the hole disappears (Fig. 2b).

Reassembling puzzles which include triangular pieces may lead to paradoxical conclusions. In this particular case, there are two paradoxes when both triangular pieces of the puzzle are transposed: an egg appears, and a substantial hole in the puzzle disappears!

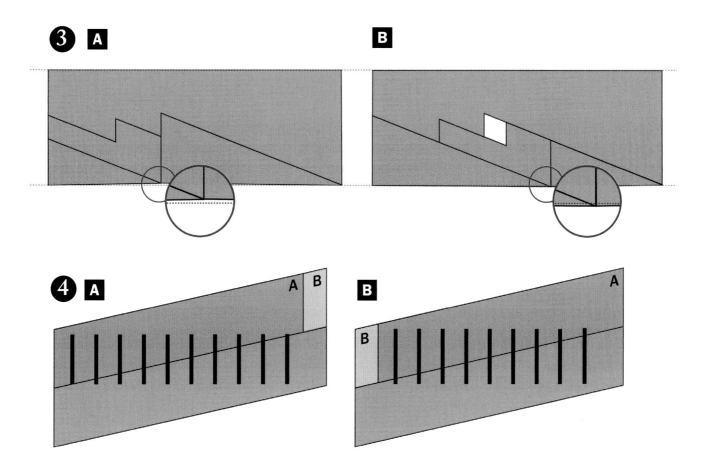

The apparent gain or loss of area can be explained by a complementary loss or gain elsewhere in the puzzle. This is due to the fact that the bases of the triangles are not perfectly aligned to form a continuous straight line at the bottom of the puzzle. In Fig. 3a, the point where the triangles meet is slightly retracted, whereas in Fig. 3b it is protruding. The area of the 'missing' surface (the hole) in Fig. 3b, is simply redistributed within this prominent line.

And what about the appearing-disappearing egg image? By switching the triangular pieces of the puzzle the egg does not disappear at all – a fraction of the image is just redistributed among the seven remaining eggs. If you measure the height of the eggs before and after the switch you will notice that there is a small difference. As a demonstration of this concept, see Fig. 4a, where 10 strokes are drawn on a three-piece puzzle. If the pieces A and B of the puzzle are transposed, a stroke magically disappears (see Fig. 4b). On close inspection, you can see that the nine strokes in Fig. 4b are slightly taller than the 10 strokes shown in Fig. 4a.

This puzzle involving the vanishing of a surface as well as the vanishing of a graphic element is a real novelty invented by the 'mathemagician' Gianni A. Sarcone.

More Visual Vanishing Effects

Here is a simpler yet interesting version of the previous puzzle. Reproduce the model in Fig. 1a and then draw simple shapes or subjects inside the eight rectangular boxes (see the example in Fig. 1b).

Cut the puzzle into three pieces by following the cutting lines (Fig. 1c). It is now possible to lay out the pieces in such a way as to make an image disappear (in this example, a post bag, see Fig. 1d).

As with the previous vanishing puzzle, the principle of this visual conjuring trick is that the tenth object did not actually disappear – it was just redistributed among the other nine. This is illustrated by the puzzle in Fig. 2a where the series of figures has been replaced by strokes. By transposing the rectangular pieces of the puzzle we can make one stroke (Fig. 2b) or even two strokes (Fig. 2c) disappear completely. You can see that in Figs. 2b and 2c some strokes are slightly taller.

Using your imagination, you can design vanish puzzles featuring more elaborate figures and scenery. In this aerial scene an extra bird appears once the upper pieces of the puzzle have been transposed (Figs. 3a and 3b).

Here is another simple yet neat variant. Reproduce and cut out the puzzle shown in Fig. 4a. When you transpose the two upper rectangular pieces you will still have three mushrooms but the egg will have disappeared (see Fig. 4b). Who ate it?

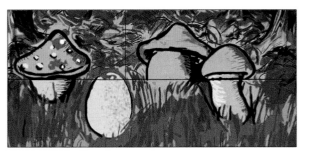

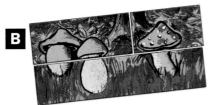

Interchangeable-body Puzzle

For this puzzle, reproduce the rectangles and pictures in Fig. 1a, then cut and fold them as indicated. You should obtain three rectangles with an image on both sides as depicted in Fig. 1b. The challenge is to rearrange these three pieces to make each hand stroke a cat or a dog without any further cutting or folding. You can use any side of the pieces to solve it.

 A

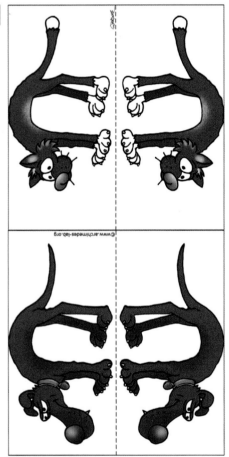

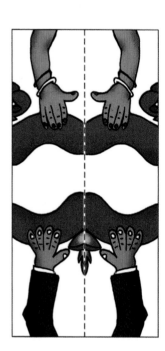

——— Cut

------- Fold

B

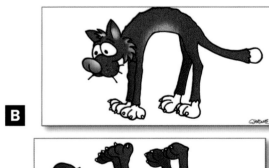

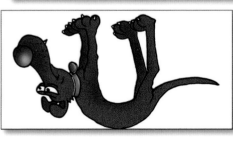

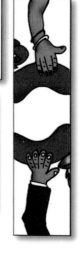

As you can see in Fig. 2, the solution is a trick – the cat and dog have interchangeable bodies!

This clever cat and dog puzzle is based on the traditional 'two-heads-four-horses' pattern. Below right, you can see an illustration of horses with intersected bodies which is a modern rendering of an artwork by an unknown Safavid artist of the 15th century. How many pairs of horses can you see in the picture? It is in fact possible to simultaneously perceive two galloping horses and two bucking horses, as demonstrated in the two boxed pictures. The 'two-heads-four-horses' pattern was popular in Asia and specifically in Safavid iconography.

This early French puzzle uses the 'two-heads-four-horses' principle. Taking inspiration from the models here, you can invent your own animal puzzle variant.

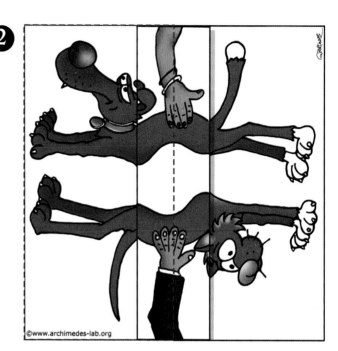

©www.archimedes-lab.org

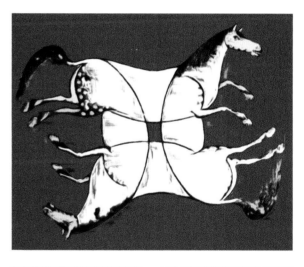

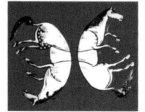
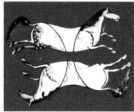

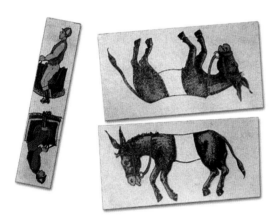

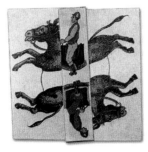

Tangram Puzzles

The Tangram, formed from seven geometric shapes, is the most popular 'put-together puzzle' and has a long history – the first books on Tangram were published in about 1800. The aim of the game is simple: to seamlessly arrange all the seven polygons of the puzzle to match silhouettes. With the Tangram puzzle you can also create great optical illusions.

Figs. 1a and 1b represent two sets of Tangram with different colours: pink and green. Reproduce both puzzles and cut them out to form the pink silhouettes in Fig. 1c and their green counterparts – but each of the green silhouettes shown here seems to have a piece missing! Both series of silhouettes are made with exactly the same seven pieces. Can you solve this visual paradox?

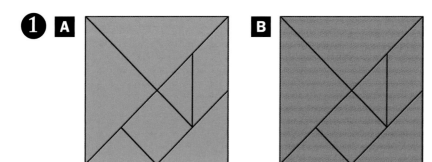

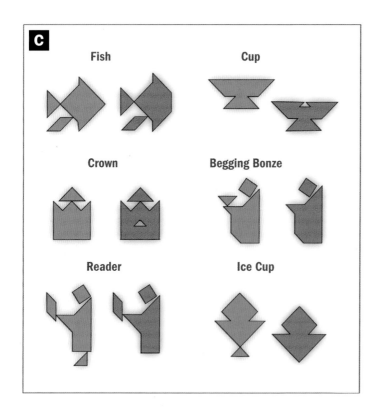

The answer is that the green silhouettes seem to be identical to the pink ones – minus a triangular element – but they are actually a bit larger. You can see that the outline of the main shapes in Figs. 2a and 2b are different. In conclusion: the missing triangular element is simply compensated for by a larger body.

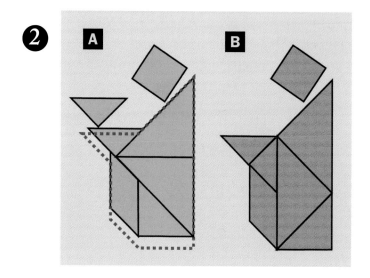

The solutions

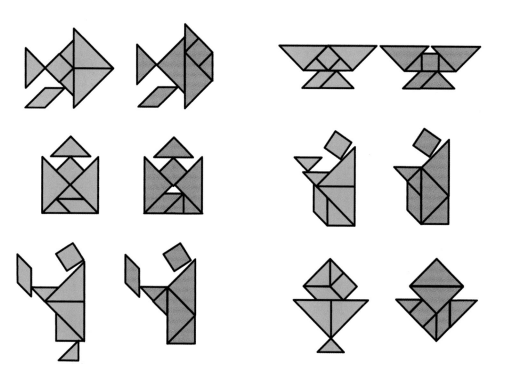

SURREAL ILLUSIONS

The term 'surreal' is used to describe a fact or an object possessing a reality of its own that arouses in us a feeling of estrangement from reality and sometimes pleasure, perhaps because it plunges us unexpectedly into a utopian world, different from the real-life one and possibly more attractive.

Surrealism is also a movement in art and literature that seeks to express the subconscious mind by a number of different techniques. Surrealist artworks feature the element of surprise, unexpected juxtapositions and unconscious associations. They provide a kind of mental illusion: they depict worlds constructed by thought in the absence of any control exercised by reason, and exempt from any aesthetic or moral concern. In this chapter we shall explore some surrealist transformations of objects and characters.

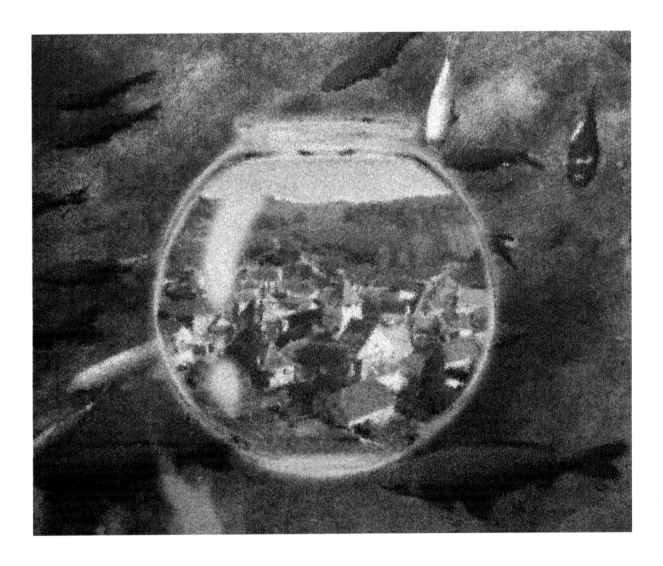

Between Heaven and Earth

A vintage reproduction of fishermen in front of a small port can prompt an idea for enhancing a marine painting: why not paint this small haven into the sky by taking advantage of the nuances of the clouds?

The blue colour of the sky can be confused with the colour of water and the houses of the port can be easily blended with the dark convolutions of the clouds, creating a sort of suggested 'haven in heaven'.

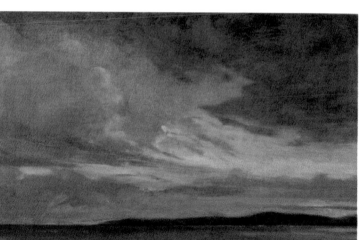

As you can see here, a kind of collage has been made by adapting the antique reproduction to the marine painting. This picture will be used as an example.

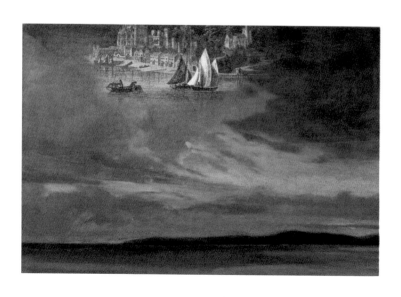

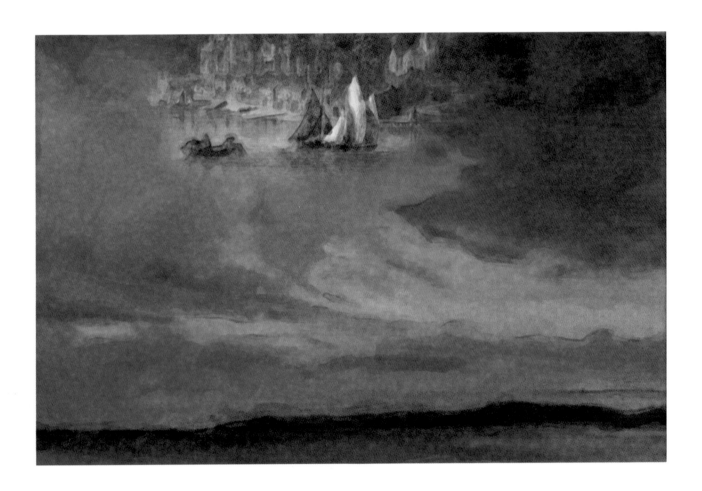

Here, the whole scene has been reproduced in
watercolour and enhanced with digital effects
in Photoshop.

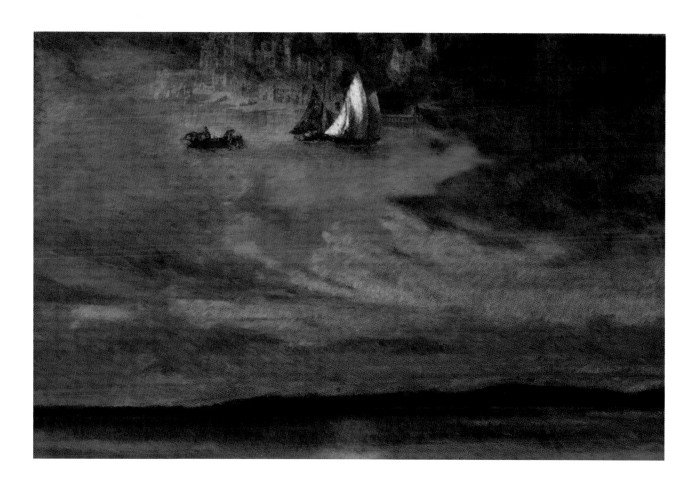

In the next picture, the sense of mystery has been increased by adjusting the white sail of the ship with white pastel so that it resembles a crescent moon – the sail of our dreams. Oil pastel colours have been added to the painting.

In this variation several mediums have been used, concentrating on sienna pigments, to give an overall impression of an old painting.

In the version below, an engraving effect has been used by shading the picture with repeated hatching lines. This can also be done with the help of drawing software such as Photoshop or CorelDraw with plug-ins such as Engraver or Cutline.

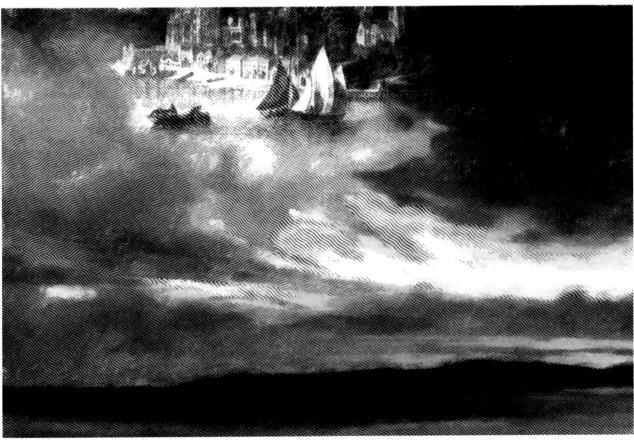

Impossible Landscapes

Empire des lumières (Empire of Lights) is one of René Magritte's most famous surrealist paintings; he did several versions, each displaying some variation on a dimly lit nocturnal street scene with an eerily shuttered house and glowing lamp post below a sunlit blue sky with puffy white clouds. The artist explained the origin of the picture in an interview, stating: 'What is represented in a picture is what is visible to the eye, it is the thing or the things that had to be thought of. Thus, what is represented in the picture *Empire des lumières* are the things I thought of, to be precise, a nocturnal landscape and a skyscape such as can be seen in broad daylight. The landscape suggests night and the skyscape day. This evocation of night and day seems to me to have the power to surprise and delight us. I call this power poetry.'

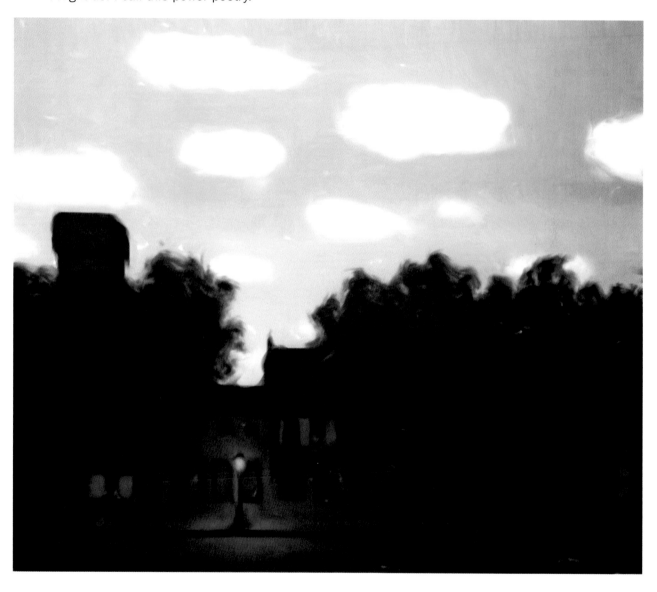

Blending together two sequences of a scene as it appears by day and by night produces a surreal impression. Magritte's picture shows an obvious and paradoxical contrast between light and dark.

To make preliminary sketches for a similar approach, select two contrasting shots, one showing a blue spring sky with white clouds, and the other showing a nocturnal view of a village.

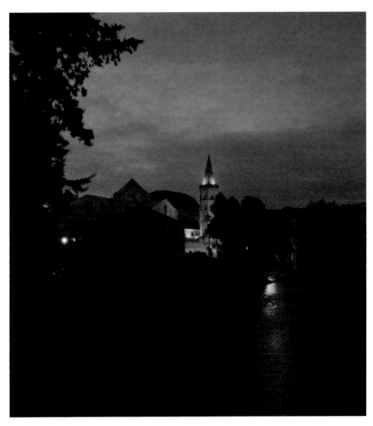

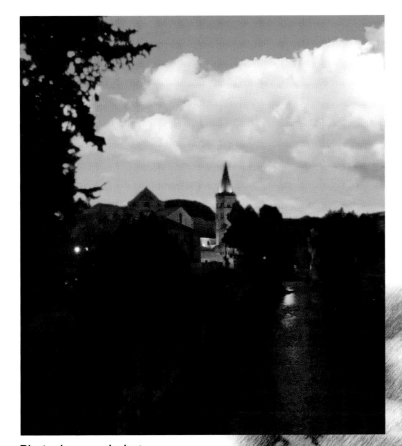

Reproduce the night-time scene, using your favourite medium such as coloured pencil, gouache, or even Photoshop, into which you can then integrate the light scene. You will need to experiment before you obtain the desired result.

Photoshop rendering

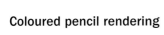

Coloured pencil rendering

In this intriguing variation, done in watercolour and gouache, what looks especially surreal is that the water should be reflecting the brightness of the sky instead of the darkness of the night.

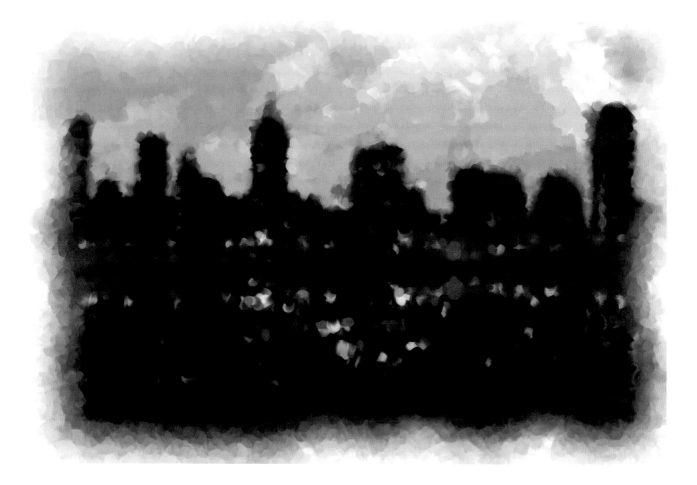

Polyphemus' Wife

An optician's advertisement showing an attractive young woman wearing glasses prompted the idea of playing with the facial features of a feminine subject. This bespectacled beauty will be transformed into the wife of Polyphemus – one of the Cyclops, a race of giants with a single eye in the middle of their forehead that features in Homer's *Odyssey*.

1 **A**

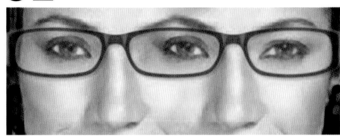

It is relatively easy to create faces in Photoshop in which the eyes, the nose or the mouth have been doubled or modified. If you are skilled in drawing you can also do it freehand. First reproduce the subject's face twice and then merge the drawings in order to obtain an intriguing face with two noses and three eyes, as shown in Fig. 1a.

B

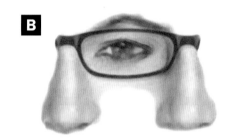

Next, adapt the central part of the picture that comprises one lens of the glasses supported by two noses. As you can see, the central eye has been enlarged and slightly modified (Fig. 1b). You can then cancel the extra features and use this as a model.

2 **A**

Now, draw or paint the face of the woman without the eyes and the nose (Fig. 2a) and fill this blank space by reproducing the model with the monocle and the two noses (Fig. 2b on the facing page). While the fabled Cyclops were not thought to have two noses, artistic licence allows you to have fun!

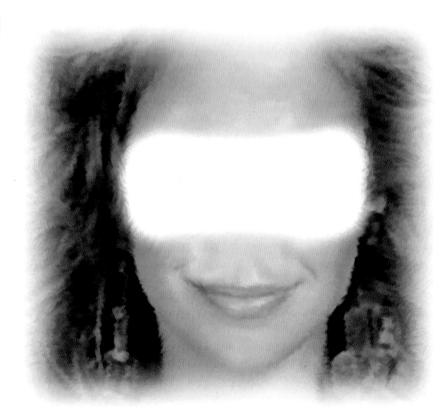

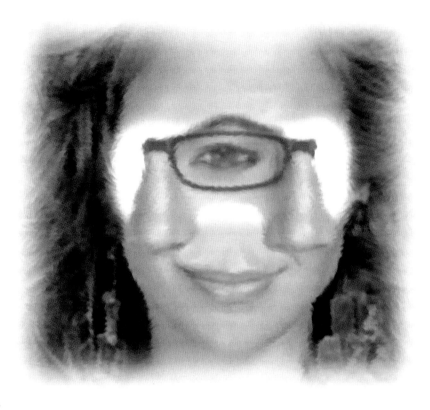

2 **B**

3

Finally, add the arms to the monocle and smoothly fill the blank spaces (Fig. 3).

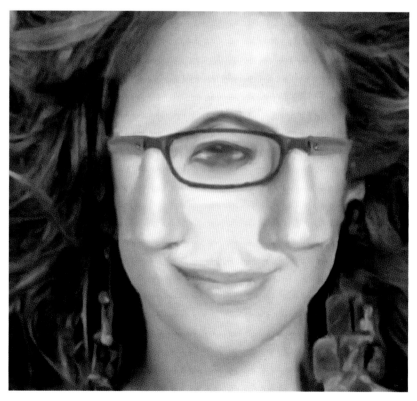

As you can see in this variation, pastel or oil painting technique on paper or canvas gives the picture very different light intensities.

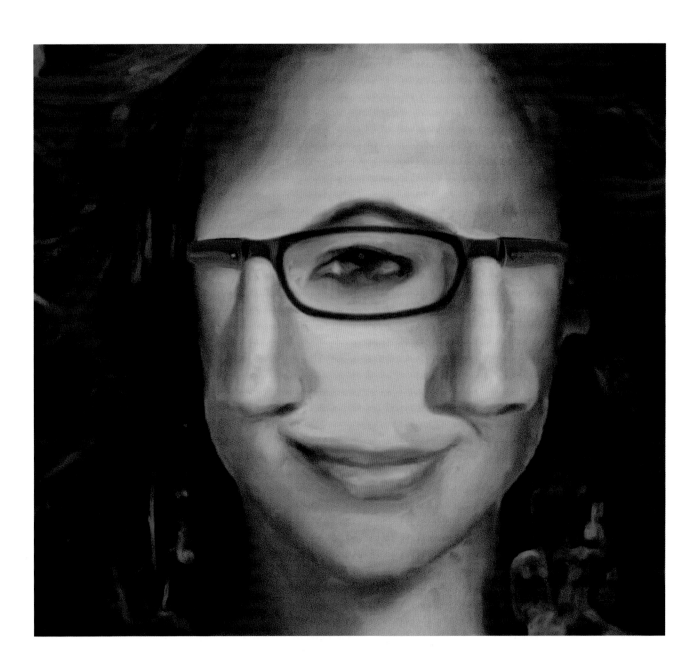

A Confusion of Faces

Surrealistic collage is a method of pasting together fragments of found pictures that already have a similar overall look in terms of scale, posture, angle of view, lighting and so forth to create new pictures with an illusionistic, fantastic, dream-like or grotesque atmosphere. Shown here are Botticelli's *Venus* (top left), Leonardo da Vinci's *Mona Lisa* (top right), Caravaggio's *Bacchus* (centre) and Andy Warhol's *Marilyn* (bottom left), and other portraits of women by Modigliani, Rubens, Parmigiano, Michelangelo, and Renoir. The goal is to make an imaginative and strange painting that assembles the distinctive visual features made by all these painters at once – in other words, to create an artistic Frankenstein portrait!

 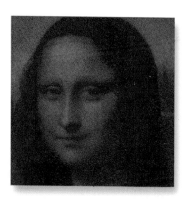

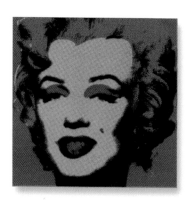

We will use a square divided into nine equal boxes as a guide (Fig. 1). Print the portraits – the print quality is not important for doing the following collage. Attribute to each box of the square a portion of the faces; for instance, the central box should contain only the nose and the left eye of the subject, while the box beneath should contain a portion of the mouth of another (Fig. 2). Continue until all nine pieces of the artistic puzzle are laid in place. Make sure that the final composed face appears the most coherent possible.

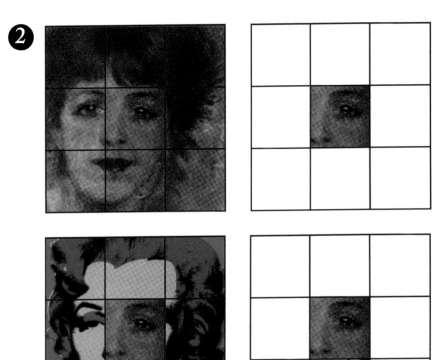

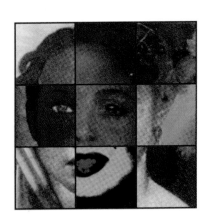

When you have finished and you are satisfied with your puzzle, reproduce it using your preferred art medium or technique. Once you have done this, try new variations of faces to see how far you can take it.

IMPOSSIBLE STRUCTURE ILLUSIONS

Depictions of solid or three-dimensional structures that seem plausible and real but are in fact illusory are called 'impossible objects' or 'impossible figures'. Some artists are able to accurately represent objects that cannot exist according to the known laws of physics by using pictorial rules to create the illusion of three dimensions, but then breaking some of these rules to make the objects impossible to construct. Illusionist artists such as M.C. Escher and Oscar Reutersvärd were really skilled in deceiving the viewer into thinking that their imaginary pictorial structures with ambiguous or incompatible connections in line drawings could be constructed in reality.

How many prongs does this fork have?
Can you be sure?

Generally, when a portion or an element of a depicted object conveys conflicting depth or position cues such as ahead/behind, front/back, above/below or top/bottom, there are chances that you are in the presence of an impossible figure, sometimes also described as an 'undecidable figure'. The notable impossible figures known as the Penrose tribar and the Penrose stairs (see below) contain ahead/behind and top/bottom depth-contradictions respectively.

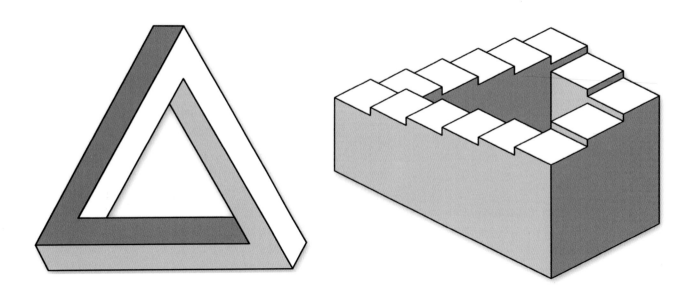

Drawing an impossible structure is possible by combining two or more contrasting viewpoints of the same object, or by blending together the perspective of one object with another. The more 'normal' and 'simple' an impossible object looks, the more fascinating it becomes. Indeed, impossible figures are not created to baffle your eyes; they are designed to confuse your mind – to be precise, your acquired visuo-spatial skills and stereographic knowledge.

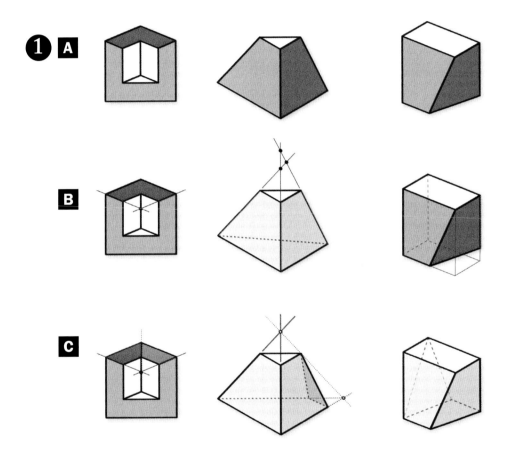

Impossible stereographic figures can be divided into two particular classes: the class of figures that seem possible but actually are not, called 'likely figures', and figures that seem impossible but are actually possible, called 'unlikely figures'. Fig. 1a shows two solids that seem possible (likely figures) – the Huffman's corner, and a truncated pyramid – along with an apparently impossible rectangular antiprism (antiprisms are similar to prisms except the bases are twisted relative to each other). In Fig. 1b, you can see the perspectival proofs of their impossibility or otherwise. Fig. 1c shows how by effecting some minor physical corrections to the Huffman's corner and to the impossible truncated pyramid they actually become possible, while the unlikely antiprism needs only an imagining of how to reconstruct the hidden faces in order for it to become a possible object.

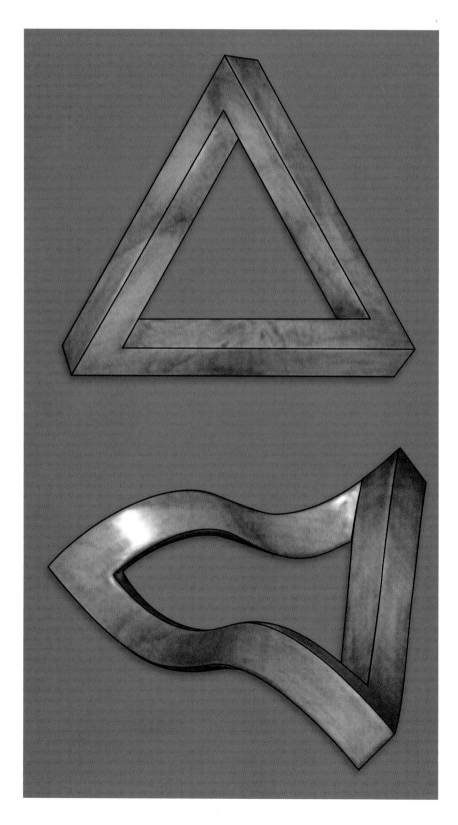

Curiously enough, many of the so-called impossible figures can be shaped as actual physical models. Our visual mind may in fact interpret (or misinterpret) these three-dimensional impossible renditions as solid sculptures if they are viewed from a certain angle. In the example on the left you can see a reproduction simulating a Penrose tribar if viewed from a particular perspective. The classic Penrose tribar looks like a solid object made of three straight beams of square cross-section which meet pairwise at right angles at the vertices of the triangle they form. Yet this combination of properties cannot be realized by any three-dimensional object in our ordinary Euclidean space!

Impossible Dice

We shall begin this illusion with a basic exercise: drawing a simple everyday object that will puzzle many observers.

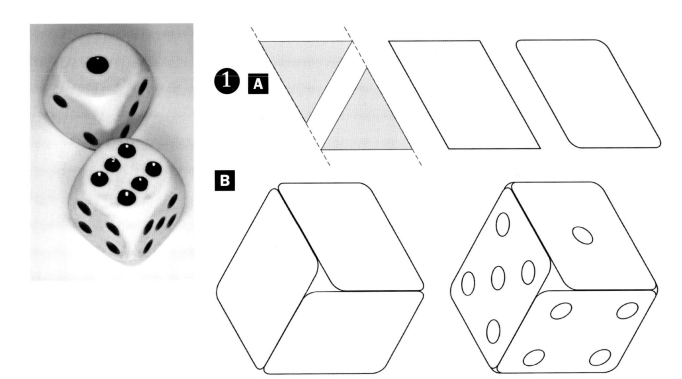

Trace two equilateral triangles and connect their vertices together as shown in Fig. 1a. Then round the vertices of the shape to obtain a particular parallelogram that will form a kind of hexagon when tessellated with two other similar parallelograms, as depicted in Fig. 1b. Finally, by adding some dots to the hexagon-like figure, you will obtain an impossible six-sided dice with round corners. (Since classical antiquity it has been traditional to arrange the numbers of dots on dice so that opposite faces add to seven.) On the final sketch of the dice, you can see that the length and width of the adjacent faces do not coincide exactly: their edges do not meet at one specific vertex.

C

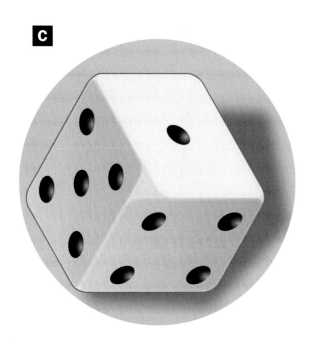

Colour the faces of the dice with different ivory shades, then add graduated shading to the dots. Finally, a cast shadow will give an overall realistic impression of depth to the drawing (Fig. 1c).

D

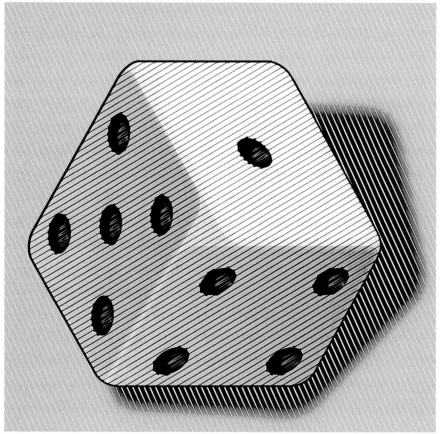

You can also enhance the drawing with an etching effect (Fig. 1d). You can do this by hand or by using drawing software with specific plug-ins such as Engraver from Alphaplugins or Cutline from Andromeda.

In this interesting variation, the assemblage of three impossible dice increases the effect of visual oddity.

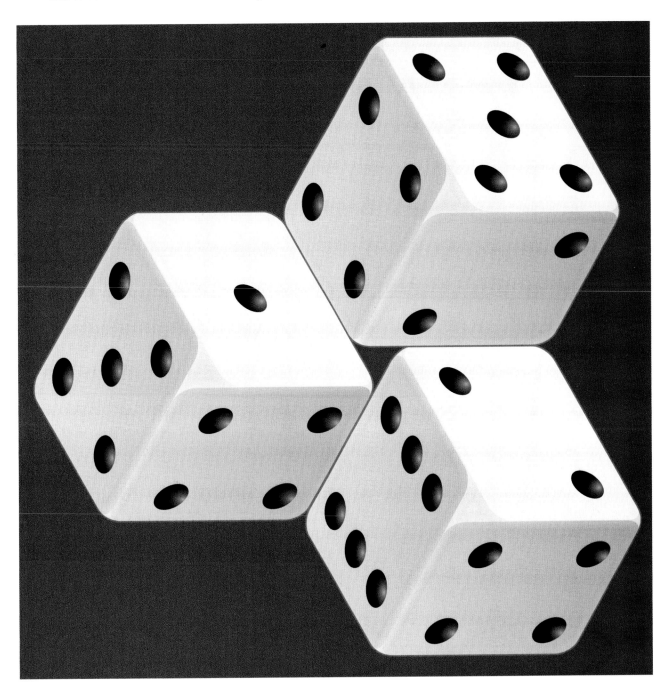

Impossible Rolling and Folding

Right-angled impossible structures give you countless variations to play with, but as artists are creative people, why not try to invent something new in the world of three-dimensional paradoxes with some rounded structures? Take inspiration from the simple representation of a rolled foil or sheet shown here.

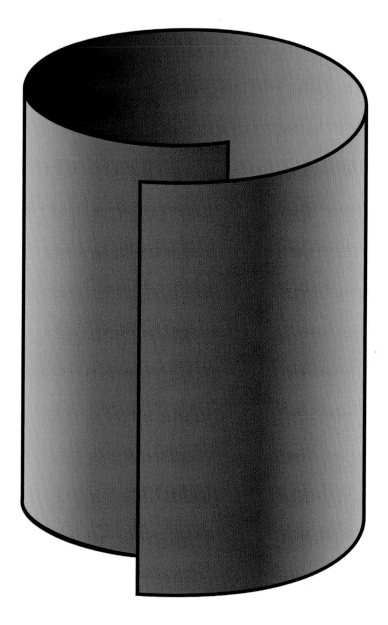

Using a pigment pen, trace a series of elementary spirals (Fig. 1) on to graph paper. Then use these spirals as a starting point for drawing several sketches of the depicted rolled sheet by breaking some perspectival rules.

1

❷

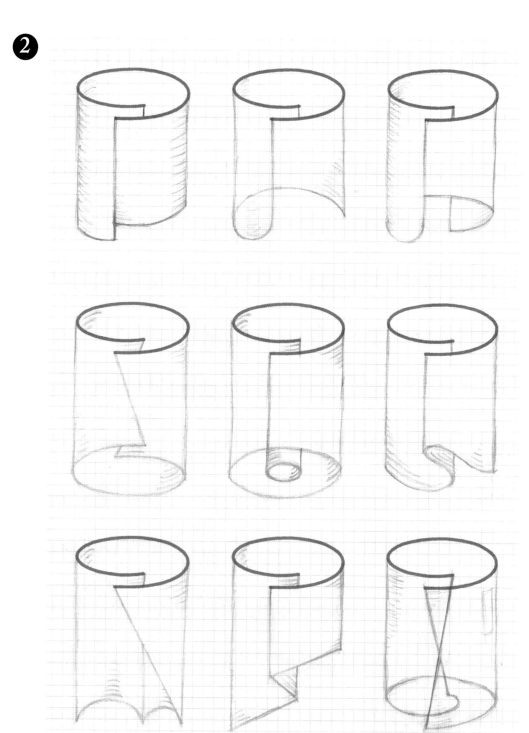

Visualize the rolled sheet as a wireframe or as a transparent object, then imagine two or more contrasting viewpoints of this object and blend them together. As you can see in Fig. 2, though the line drawings seem coherent they are incompatible with an actual perspective.

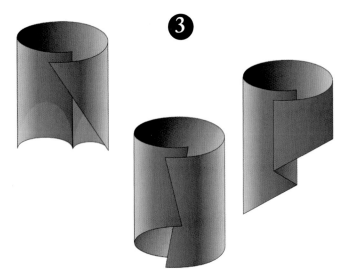

3

When you have made enough sketches, select two or three models that seem the most satisfying and colour them slightly to strengthen the illusion effect (Fig. 3). Do not hesitate to try different media or art styles.

You can then decide to design more complicated spiralling or round impossible structures such as those shown here.

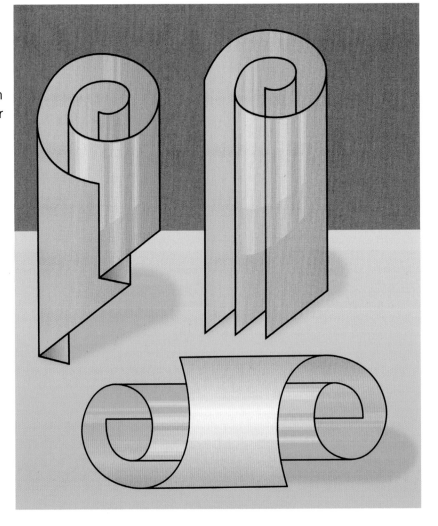

Concave Versus Convex

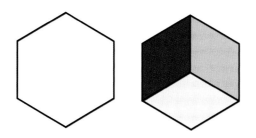

Using the outline of a hexagon, you can create a basic cell that simulates a concave space or convex shape at once. In fact, with such a cell it is possible to generate a design pattern of ambiguous cubes which can be read as solid or hollow according to the direction in which you imagine the light to fall.

1

2

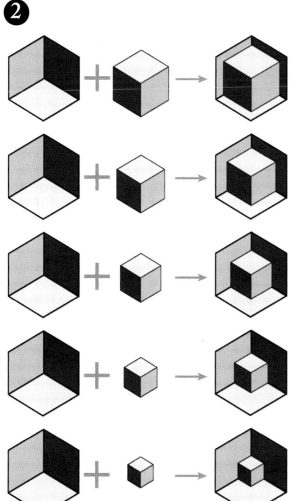

However, here we shall use this basic cell as a starting point to create new pattern variants. Turn the basic cell upside-down, then reproduce this cell six times, reducing it to approximately 85 per cent at each step (Fig. 1). The assembling of the basic cell with these new elements creates a variety of shapes that look like cubes with a missing cubic corner, or like hollow cubic spaces with a solid cube in the corner (Fig. 2).

You can paint the cells with vivid colours and assemble them as shown in Fig 3.

❸

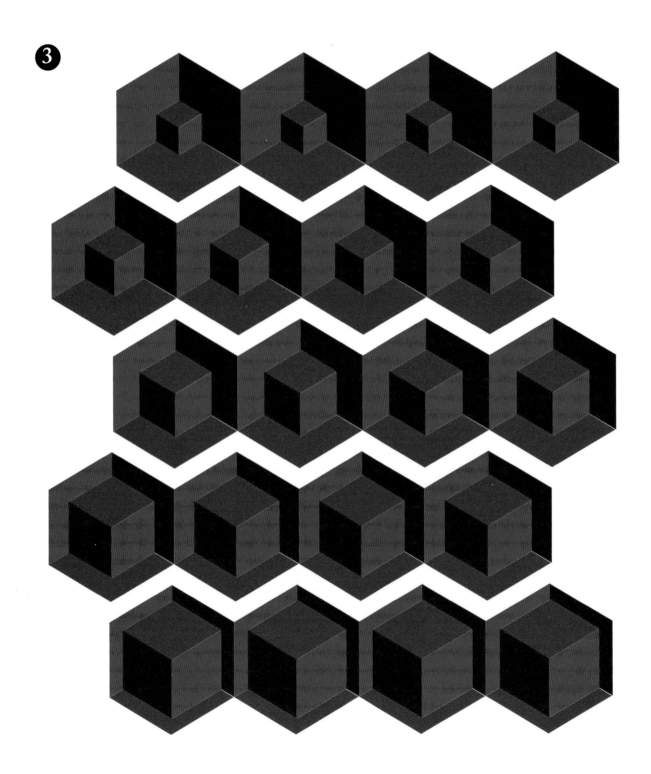

By using the cells as tiles it is possible to create very complex tessellated designs (Fig. 4).

4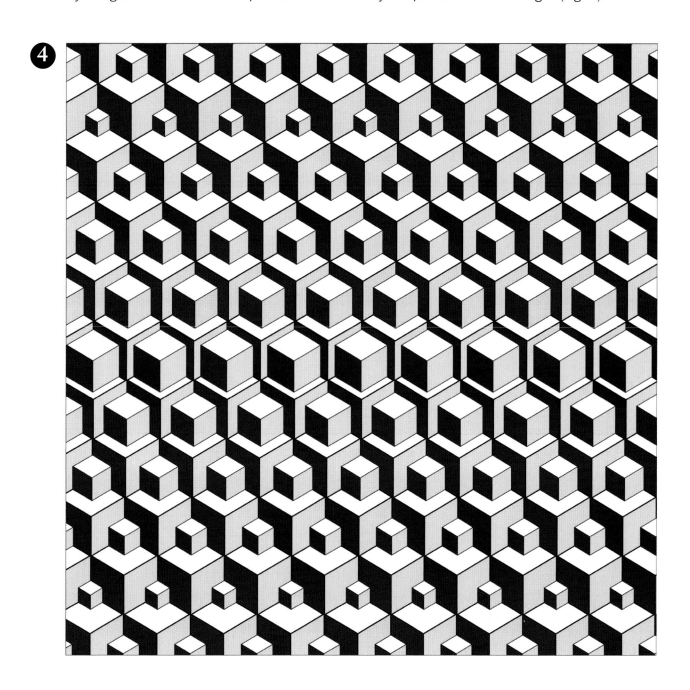

You can also combine two distinct pattern designs to create an illusory motion effect. To create this kind of bulging effect, in Photoshop select the object and, in the Filter menu, use deformation option -> spherization. In Illustrator or Freehand, select the object and, in the menus 'Object' and 'Transform' respectively, use envelope option -> circle.

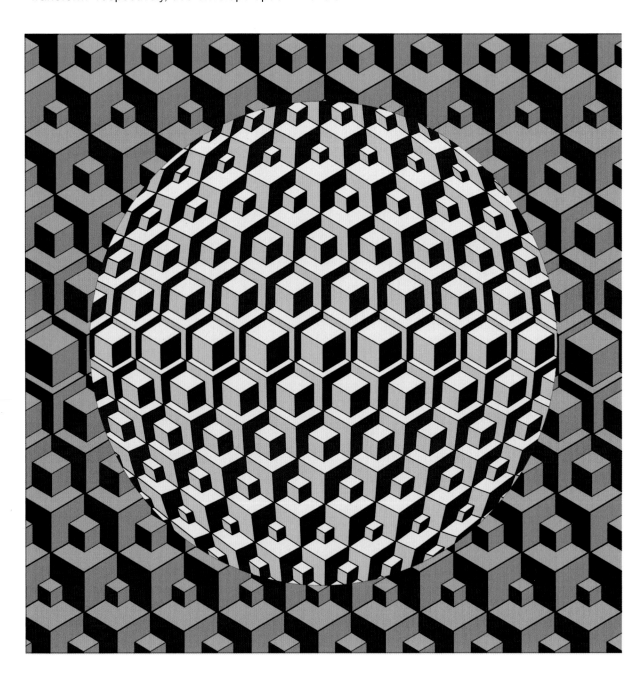

If you proceed with your creative process you can invent more complex basic cells just by following the previous construction method. As you can see, the assembled elements that form these new basic cells are a bit more complicated. When these cells are turned upside-down, the visual effect changes (Fig. 5).

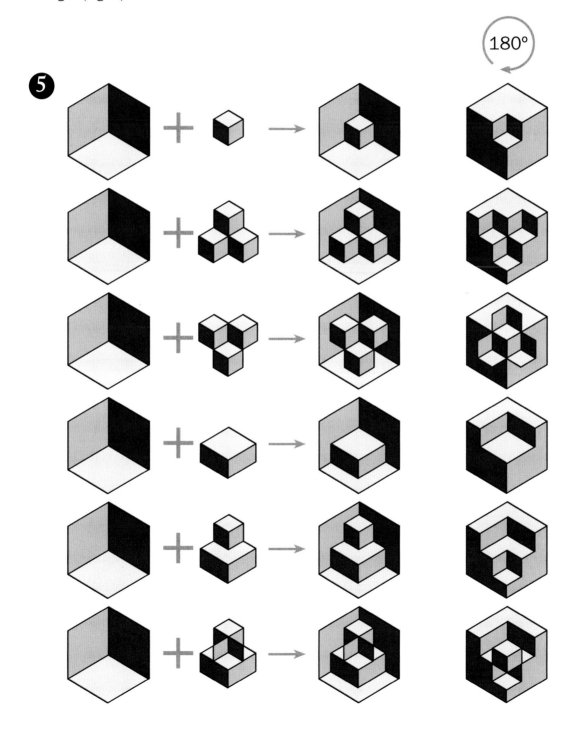

Using these new cells as tiles you can create a huge variety of patterns. In Fig. 6 two different cells have been used: a regular one and its 180-degree rotated counterpart.

 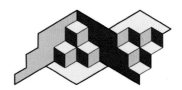

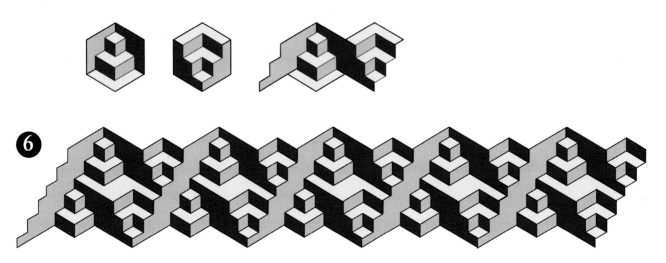

6

Outward and/or inward cubic spaces are very confusing in the example here!

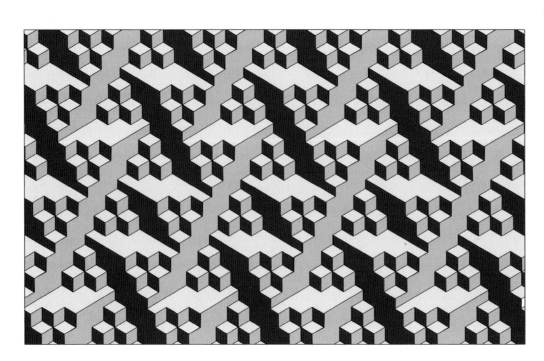

Illusory Transparencies

Everyone knows those impossible bottles that have an object inside them that does not appear to be capable of fitting through their neck (traditionally a ship). Well, here we will go one better: we will introduce into a flat bottle a solid object that is even larger than the bottle itself!

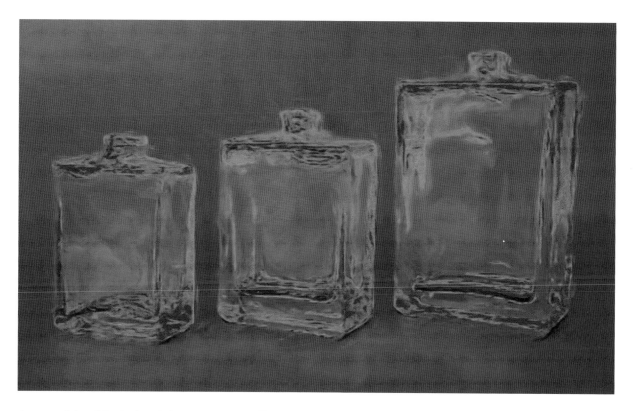

Impossible objects involving transparency are very rare. But how to draw and paint transparent objects such as glasses and bottles? A strong feeling of transparency can be given by drawing light but well-defined areas, as shown in the example above. However, you will have to practise and do several trials before achieving a good result. Watercolour and gouache are good mediums to use with this technique to start with.

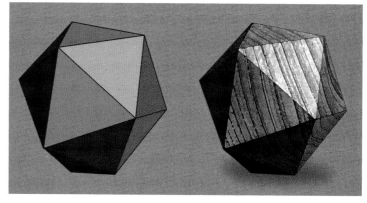

As the goal is to paint a solid that seems impossible to fit inside a flat bottle, an icosahedron – a solid figure with 20 identical faces – is perfect to stress the protruding effect, incompatible with the dimensions of the bottle.

Following the example shown here, reproduce the flat bottle and the relative inner icosahedron with a soft pencil before trying several painting techniques.

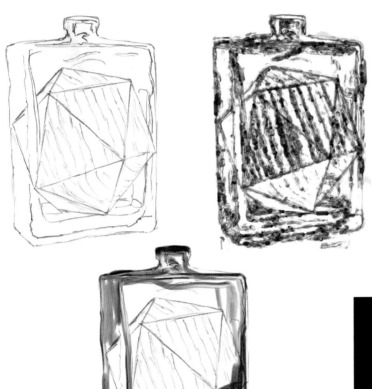

And here is the most curious impossible object ever seen!

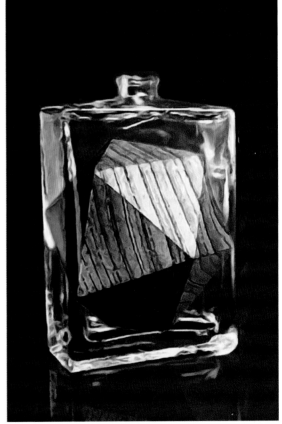

A Magic Staircase

The kind of staircase you will be tackling here is a novelty in the world of optical illusions. In fact, the architectural structure of the staircase is made in such a way that when a person tries to climb the stairs he or she actually goes down, and vice-versa.

① **A**

B

Draw two orthogonal straight lines and then between them draw a set of stairs (Fig. 1a). Then reproduce in scale the same set of stairs clockwise within the spaces delineated by the straight lines (Fig. 1b).

The decreasing sets of stairs, joined together by the ends, will create a sort of unending rectangular spiral. When you think you have made enough sets of stairs, colour the four walls of the stairwell with neutral graduated shades (the bottom of the stairwell being obviously darker and the top lighter – see Fig. 1c).

C

D

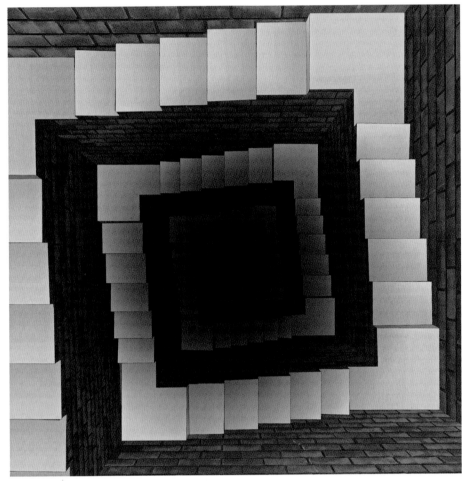

According to your skills, you can also add brick-like textures to your drawing to make it more realistic (Fig. 1d).

The final touch is given by adding people, viewed from above – for this purpose you can use Clip Art or stock photography subjects.

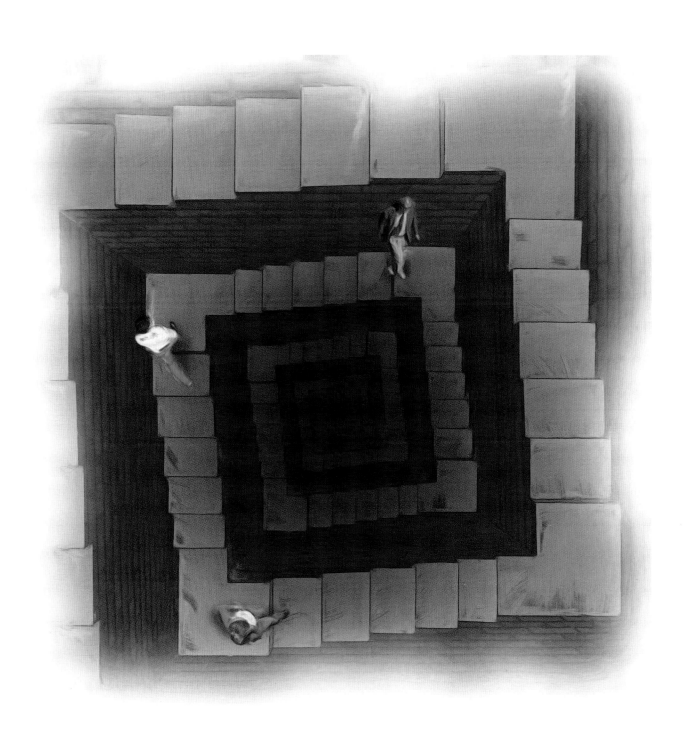

CHROMATIC ILLUSIONS

Our eyes interpret colours in surprising ways. We never see colours in isolation and the appearance of any colour is affected by what surrounds it, be it another colour or just white paper. Under certain conditions, colours that are identical may appear to be different, and colours that are different may look the same. Such an effect is called colour or chromatic induction. There are two main kinds of colour induction: simultaneous colour contrast and colour assimilation.

Simultaneous colour contrast occurs when the difference between opposing colours is enhanced by their juxtaposition – for example, reds look redder when placed against green. On the same basis, a grey area tends to look greenish when set against a red background, but will appear reddish against a green background.

Colour assimilation (also known as the Von Bezold spreading effect) is the opposite of colour contrast: colours take on the hue of the surrounding colours. For instance, a small white area tends to look pinkish against a red background. While the mechanisms of colour contrast phenomena are well understood, how and when colour assimilation occurs is still not completely explained.

The odd thing about seeing colours is that some, such as magenta, are not in the colour spectrum, meaning they cannot be generated by a single wavelength of light. Our brain interprets the colour sensation of magenta as absence of green. In the case of brown, which also does not exist in the spectrum, our brain invents it in response to a particular low red-orange stimulus.

So you can see that the qualities of colour are ripe for intriguing optical illusions, and in the following pages you will learn some basic techniques to create them.

Though there is no blue tint between the blue lines, the curvilinear path appears slightly shaded with blue (in fact, the background is uniformly white!). This shading effect is called 'subjective transparency', 'spreading neon colour effect', or even 'Tron effect'.

The Perception of Brightness

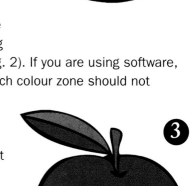

In this demonstration we shall play with the perception of colour brightness. In short, while you may feel you can distinguish differences in the brightness of colours, only specific instruments can measure the 'luminance', or actual brightness, of a colour. Brightness is indeed a very relative sensation.

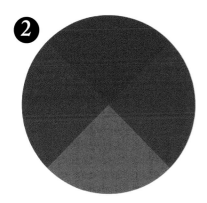

Sketch an apple or any other green or red fruit with a soft pencil and, once you are happy with your design, ink it with a pigment pen (Fig. 1). If you prefer, you can use drawing software to do this. Then paint four distinct zones in a circle with flat green or red colour, each having a different percentage of brightness (Fig. 2). If you are using software, the difference in brightness between each colour zone should not exceed 30 per cent.

Reproduce (or paste) those four colour zones within the apple outline. In the example in Fig. 3, you can still perceive four different zones. But what happens if you conceal the brightness boundaries of the colour zones with black thick lines (Fig. 4)? You see the apple as having a uniform colour!

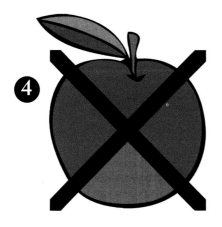

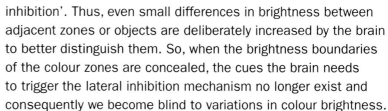

This occurs because in our visual system there is a mechanism that enhances the contrast of the outline of an object relative to its background: it is called 'lateral inhibition'. Thus, even small differences in brightness between adjacent zones or objects are deliberately increased by the brain to better distinguish them. So, when the brightness boundaries of the colour zones are concealed, the cues the brain needs to trigger the lateral inhibition mechanism no longer exist and consequently we become blind to variations in colour brightness.

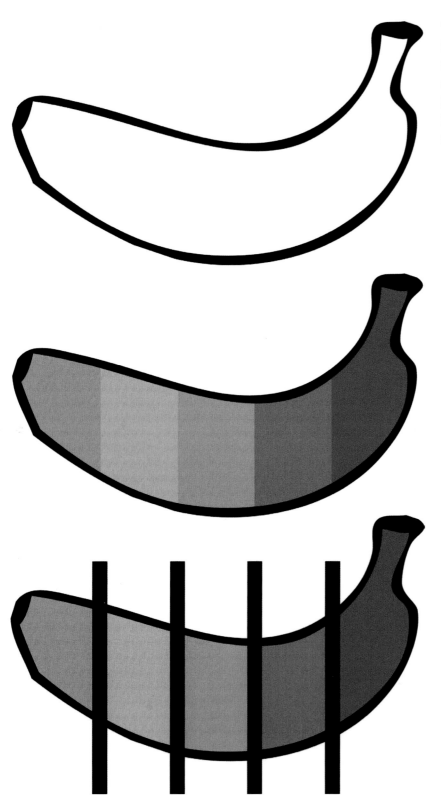

You can also use the same technique with a banana by using bands of yellow in different shades. Once the brightness boundaries are hidden by thick black vertical lines, the colour of the whole banana looks even.

Playing with Colour Assimilation

All the colours you see on a television screen are combinations of three basic colour phosphors, or fluorescent lights, in red, green and blue (Fig. 1). Now we will use those combinations to do an interesting experiment with colour assimilation.

Arrange three lines in red, green and blue (Fig. 2), then reproduce them to make a larger rectangular pattern with alternating red, green and blue colours (Fig. 3).

Next, trace three large simple maths signs on this pattern so that each is vertically enclosed between two lines of the same colour. For example, in Fig. 4 you can see that the addition sign is enclosed between green lines, the multiplication sign between red lines, and the division sign between blue lines.

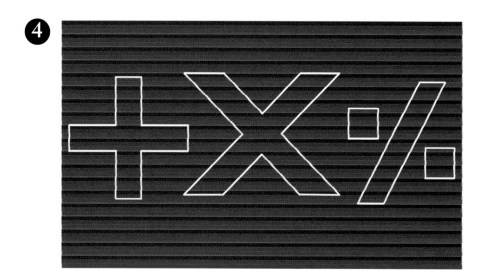

4

For the next step, replace all the green lines inside the addition sign, the red lines inside the multiplication sign and the blue lines inside the division sign with solid white lines (Fig 5). As a result, you have obtained a surprising optical illusion: the symbols seem shaded with pink, cyan and yellow though they are made with white lines.

5

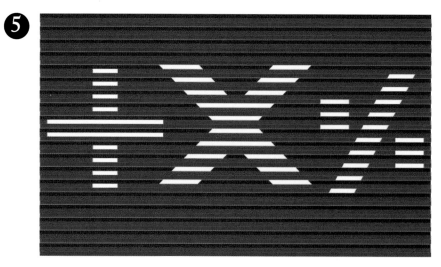

Instead of white, you can fill the symbols with solid black lines (Fig. 6). Again, the effect is astonishing – you can see colours where in reality there are only black lines. You can also employ the complementary colours of magenta, yellow and cyan to create the background pattern. Using the same technique with white lines, you will perceive slightly shaded rather than white symbols (Fig. 7).

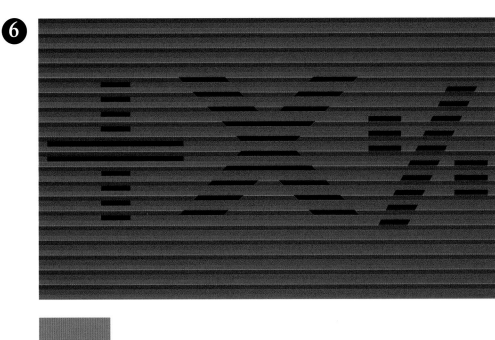

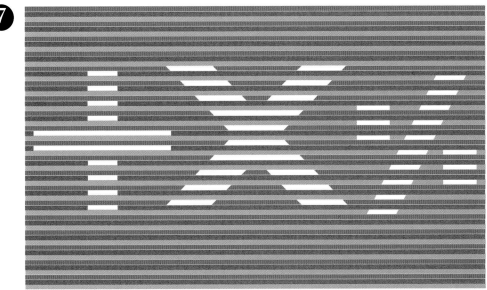

Alternatively, you can use shapes such as discs or squares to perform incredible colour illusions. This experiment allows you to try a multitude of variations.

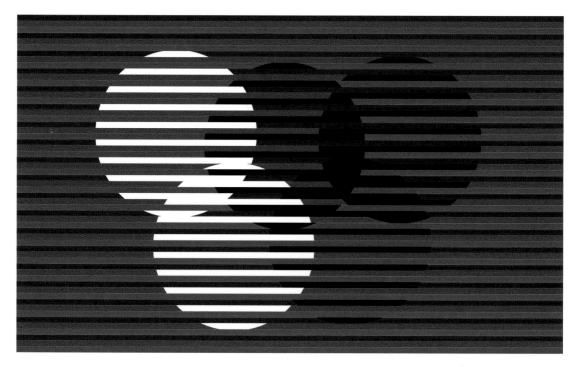

The Illusion of Motion

This chapter concludes with a simple yet compelling illusory motion effect involving colours. This kind of illusion is related to 'peripheral drift illusion' (PDI) and is generated by repeated contrasting patterns in the peripheral vision and by unconscious random eye movements (saccades).

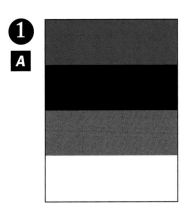

In a rectangle – the 'cell' – arrange a series of contrasting colours including black and white, as depicted in Fig. 1a or 1b. The colour of the background is important – select a neutral colour such as light grey or brown. Then reproduce this cell five times, reducing its size to 70–80 per cent at each step, and display this set of decreasing cells radiating out from a circle (Fig. 2).

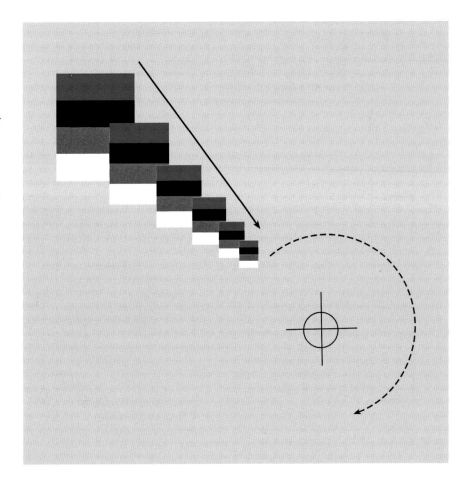

③

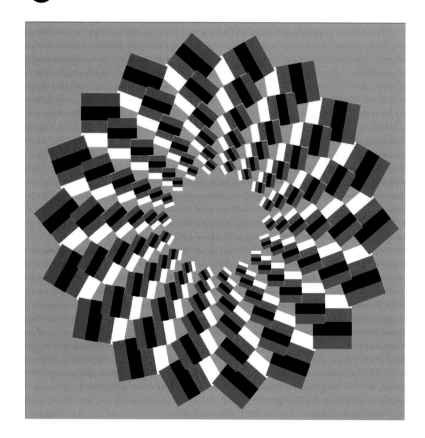

Repeat the pattern around the whole circle as shown in Fig. 3.

Now the radiating colour pattern seems to rotate when you sweep your gaze around the picture, even though the image is perfectly static.

You can enhance the illusory motion effect by slightly blurring or widening the details of the pattern and by repeating it in a symmetrical fashion.

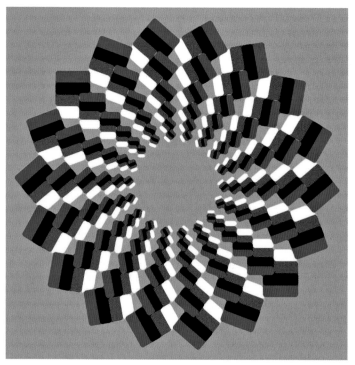

You can also try other variants by inverting or changing the order of the colours. You may find that those with more strongly contrasting colours work better, but what specifically changes is the virtual direction of the rotation: some discs will appear to rotate clockwise and expand, while others seem to counter-rotate and shrink.

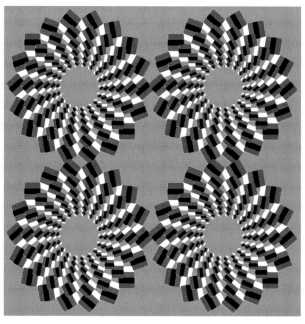

BISTABLE ILLUSIONS

It often occurs that particular figures, known as 'bistable figures', may engender fluctuations in visual awareness because they offer alternative, contradictory interpretations. The brain resolves the perceptual contradiction by favouring first one interpretation and then the other (when it is finally perceived). The attention on one rather than the other interpretation is influenced by personal factors such as stored knowledge and experience.

Bistable figures provide a fascinating window through which to explore human visual awareness. Figure-ground, composite and reversible figures are all members of the same large bistable-figure family.

Figure-ground illusions swap the main figure and its background, while composite, or multipart, figures are generally subjects composed of many other smaller figures, for instance a man's face formed with smaller feminine bodies. The Italian Renaissance painter Giuseppe Arcimboldo was famous for his imaginative composite portrait heads represented by an arrangement of trivial objects such as fruits, vegetables, flowers and so on.

Reversible figure illusions are pictures that can be interpreted differently when rotated by 90 or 180 degrees. The orientation of an image on the eye's retina plays an important role in the identification of a figure, and especially of human faces. For instance, in the case of an upside-down world map, even if the countries are named it is hard to recognize which is which at first sight, because the mechanism that should put the upside-down image in its context is literally disoriented; in effect, faces and maps contain too much detail to work out! Even a simple geometric shape can appear different when turned 90 degrees: for instance, a square becomes a rhombus and looks larger.

Since antiquity, many artists have played with such visual principles by creating puzzlingly ambiguous bistable pictures. In the following pages you will learn some basic techniques to create such intriguing optical illusions.

Confusing Babies

Mythological creatures with overlapping or interchangeable bodies, heads and limbs were popular in medieval iconography. The overlapping body parts symbolize the transition states or cycles by which inner potential becomes the actual sequence of events, while the static elements (generally heads) represent a metaphor for constancy amid change. In the Renaissance example below you can see three babies' heads with seven possible distinct bodies.

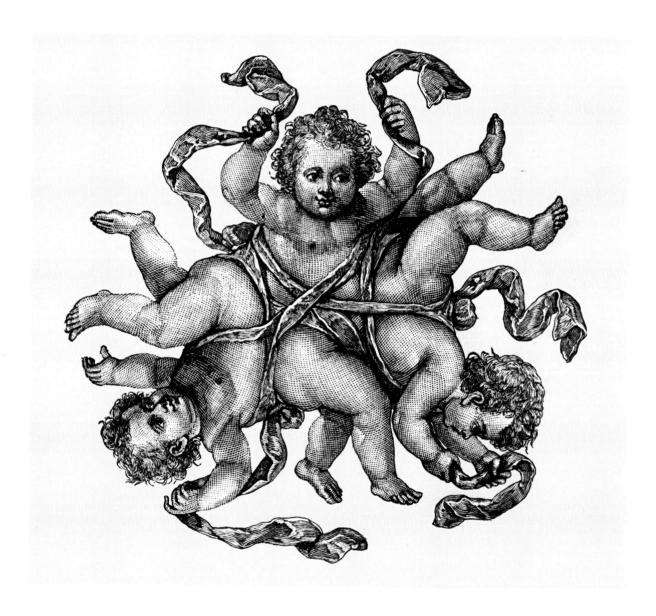

In this experiment we will bring the spirit of this old print of multipart babies up to date. First of all, you need to adapt the faces. Find some baby portraits (Fig. 1) that are suitable for use in the redrawing process of the illusion.

1

2

With a soft pencil, reproduce the original picture but replace the heads with the current ones (Fig. 2).

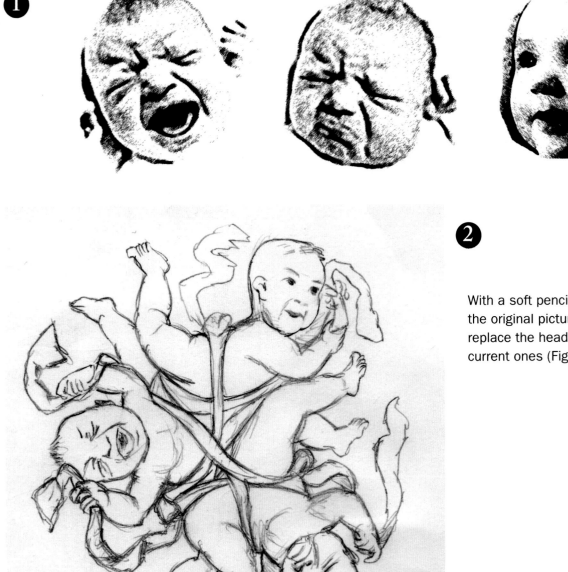

Ink over the sketch, rub out any pencil marks and make several
photocopies of your artwork (Fig. 3).

3

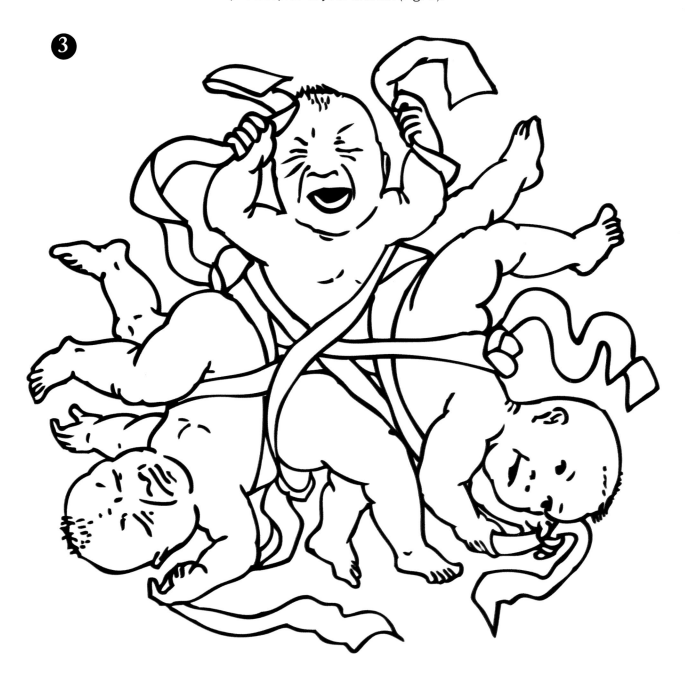

The photocopies will allow you to try several colour variations, as you can see in the following examples (Fig. 4). Shading is important to give volume to the figures and emphasize the feeling of oddity.

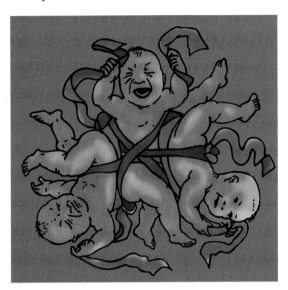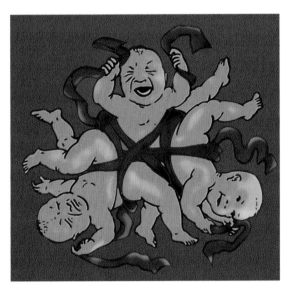

You can see in Fig. 5 the visual proof that three heads are actually shared by no fewer than seven distinct bodies.

Induced Images

'Figure-ground illusions', where an image is hidden or suggested in a host image, are the best-known type of ambiguous figures. Some figure-ground illusions are obvious: the image is only suggested but is perfectly visible. In others, the image is hidden, but guided by visual cues your eye spots it after a while. To be perfectly invisible, the 'inducing' hidden image should not be discordant with the 'induced' apparent image, so you will need to use images that share some spatial properties or features.

1

To make an induced image, first select a greyscale picture of a face with large areas of dark tone (Fig. 1). You can use any retouching or drawing software, for example Photoshop or Paint-Pro.

Crop the image so that only the portion with the face and hair is visible, as shown in Fig. 2, and blur it exaggeratedly. Now, you have to introduce a second story to this abstract picture. Do you see a seated person under the cone of an electric light? No? Well, everyone may imagine something different. What is interesting here is that as soon as the meaning of a blurred drawing emerges you can no longer see it as you saw it before.

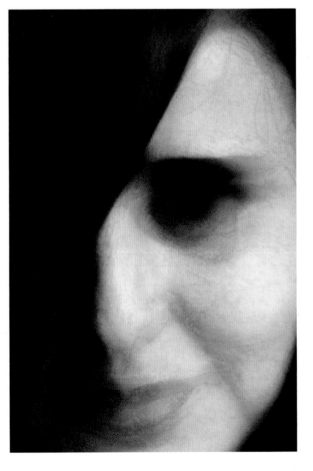

If the face is slightly retouched with a soft pencil, the details become more evident (Fig. 3).

Pastel colours add even more definition to the drawing (Fig. 4).

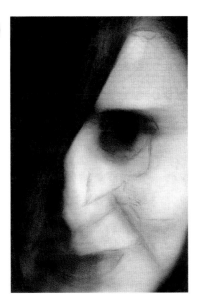

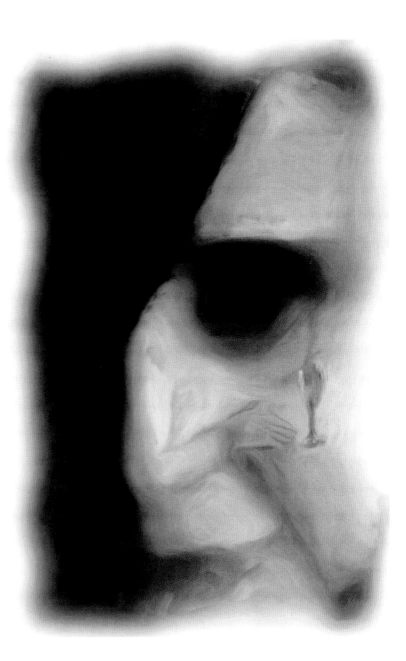

The final effect gives two readings of the same picture: seen up close, we can clearly perceive a person seated at a table, and from a distance, we also see that the picture is of a woman's face.

Dominoed Faces

Next, let us create some puzzling domino portraits by means of a mosaic tiling technique. A domino portrait is simply a rendering of an image based on a given number of sets of dominos. To create it, you can start with any image – called the 'target image' – such as a picture of Marilyn Monroe, John Lennon, Angelina Jolie or some other famous figure, and a certain number of complete sets of dominoes. The goal will be to position the dominoes in such a way that, when seen from a distance, the assemblage looks like the target image.

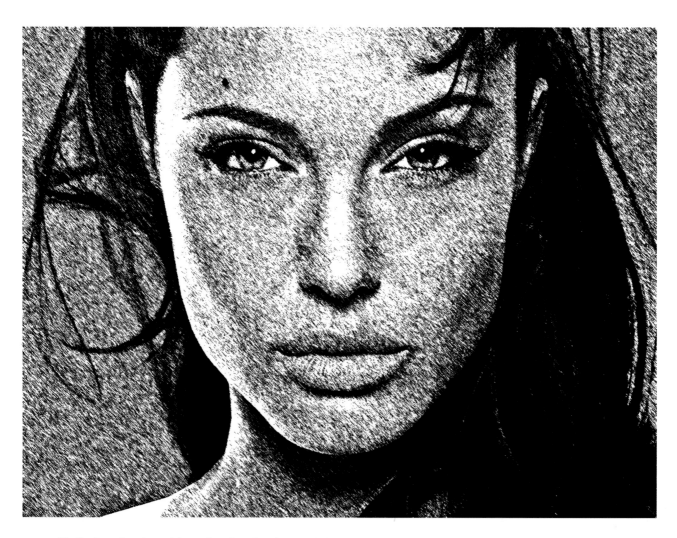

To find optimal positions for the dominoes, it is not necessary to make complicated designs or calculations. You just need one of two very simple software packages: MacOsaics (Mac) or Ezmosaic (Win). Those applications make the creation of high-resolution mosaics easy by applying a mathematical technique known as 'integer programming'. Long used in operations research, integer programming has aided a variety of large-scale planning tasks.

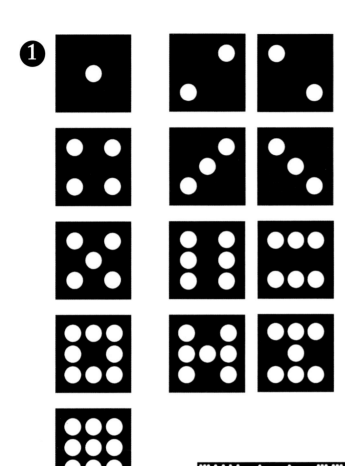

First, use your drawing software to create 13 different pictures of single black squares each containing one to nine white pips, as shown in Fig. 1, and save these images as jpg or tif format in an archive called 'image source'. It is important that these different pictures are all the same size.

The procedure to create your domino mosaic is as follows:

1. Open your mosaic application (MacOsaics or Ezmosaic).
2. Determine the target image you want to turn into a domino mosaic (here, a portrait of Angelina Jolie).
3. Choose the folder with the image source for filling in the tiles (where the 13 images of dotted squares are archived).
4. Click 'Start' and the application will start creating your domino portrait for you. Here a neat rendering of Angelina Jolie is created out of double-nine dominoes (Fig. 2).

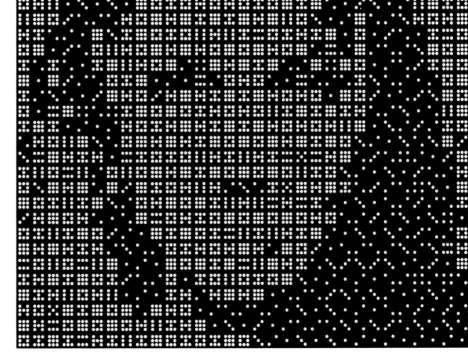

You can also use both black dominoes
with white pips and white dominoes
with black pips to achieve different
effects in your artwork (Fig. 3).

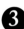

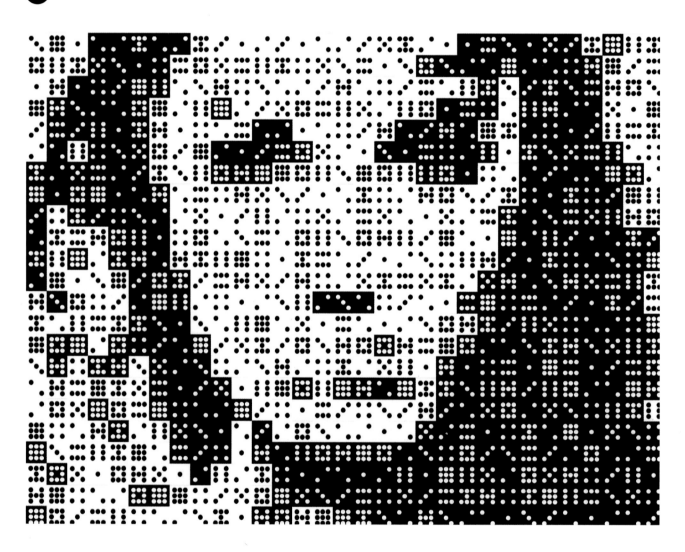

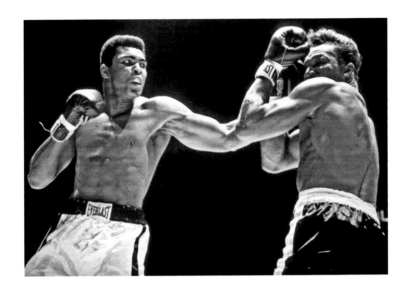

Employing exactly the same technique, it is possible to apply different shapes to the tiling of your target image. In this eye-catching example the target image is an old photograph showing the boxer Mohammed Ali in action.

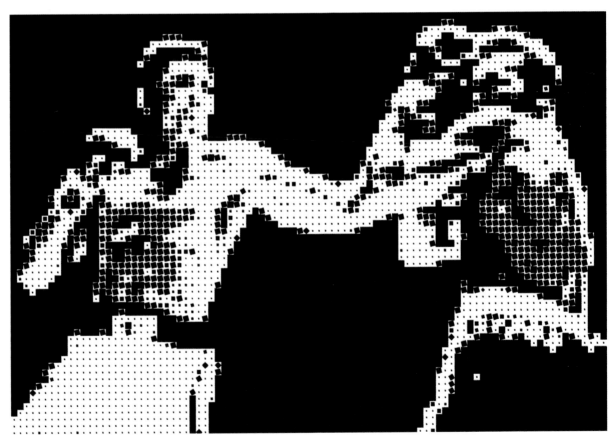

Topsy-turvy Pictures

During the late 19th and early 20th centuries, matchbooks often featured topsy-turvy optical illusion artworks. When viewed one way the matchbook would show one image, but when it was turned upside-down an entirely different image would appear.

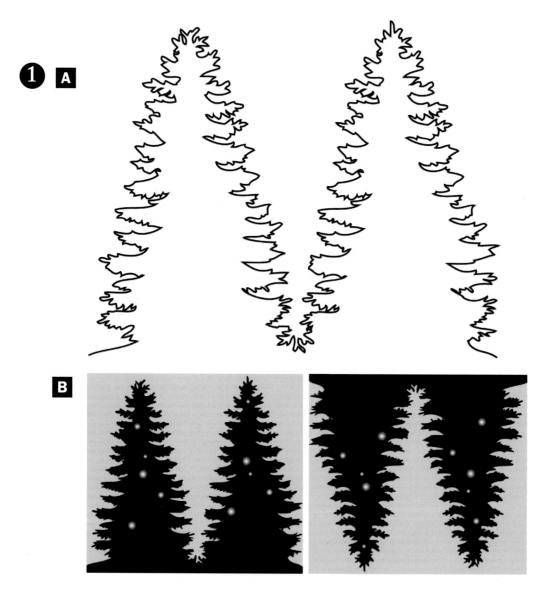

It is not difficult to sketch simple elements that retain a visual sense even when upturned. In Fig. 1a you can see a saw-toothed outline that resembles a pair of fir trees. By colouring the surface within the lines in solid black, you obtain two silhouettes of fir trees. If you add some lights, they become a pair of Christmas trees (Fig. 1b). When the picture is rotated 180 degrees you see instead a scene of a forest and a starry night sky.

The same concept can be applied to the outline of buildings in a town. Use pale and dark colours to separate the drawing into a kind of urban yin-yang (Fig 2a). If done accurately, the smoke of a chimney stack will turn into a stream or a river when the drawing is inverted (Fig. 2b).

2

A

B

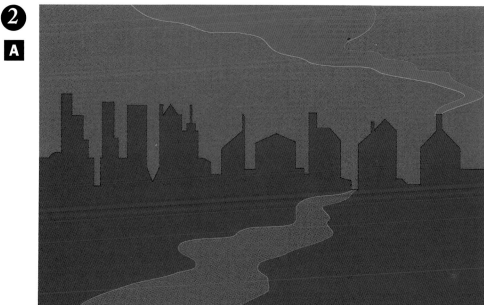

To improve the confusing effect of your topsy-turvy picture, play with a variety of ways to add more details such as illuminated windows, distant buildings in the background and even a moon which may change into the sail of a craft (Fig. 2c). If you are working in black and white, you can also increase the greyscale contrasts to give a more punchy image with deeper blacks and strong highlights (Fig. 2d).

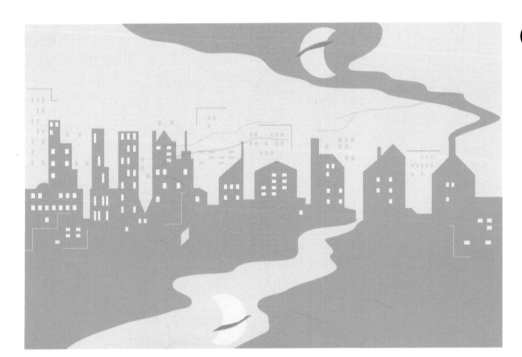

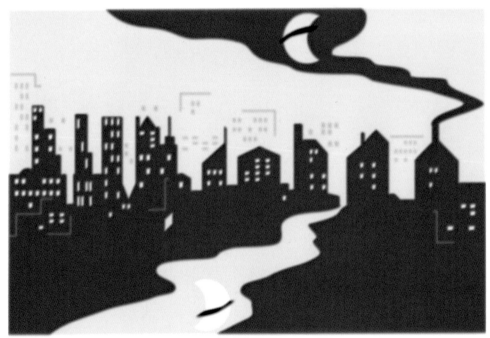

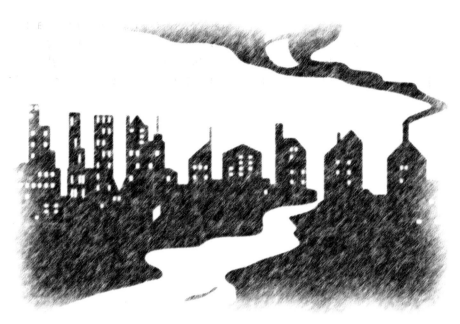

You can use one or several art techniques to achieve your desired results. These variations were created using a combination of hatching, pen and wash and computer graphics.

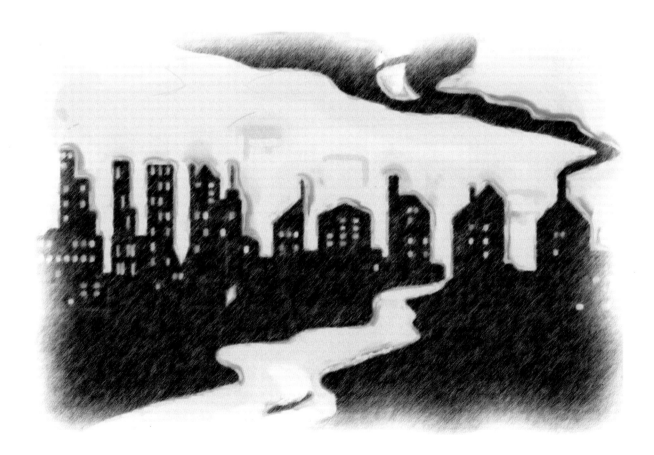

AMBIGUOUS ILLUSIONS

Ground is often thought of as background or negative space – an empty non-form that gives shape to the figure. In painting, 'figure-ground' refers to the relationship between an object and its surroundings. Sometimes the relationship is stable: it is easy to pick out the object, or figure, from the ground. Other times the relationship is unstable, meaning it is difficult to distinguish the figure from the ground. Occasionally the relationship is ambiguous, meaning that the figure could be the ground (and vice-versa), or hidden in the background.

We shall also explore camouflages in this chapter. Everyone is familiar with the idea of camouflage as a visual 'noise', usually made from line or dot patterns, that enables creatures to blend in with their surroundings – but it is also possible to encrypt enough information in a set of lines or spots to make a figure appear under certain circumstances. The figure is there, partially hidden, but you have to mentally organize parts of the camouflage into a meaningful pattern in order to see it. Once you understand what is being presented your perception will change, because from now on it will be impossible for you to focus on only the apparent figure without paying attention to the hidden image.

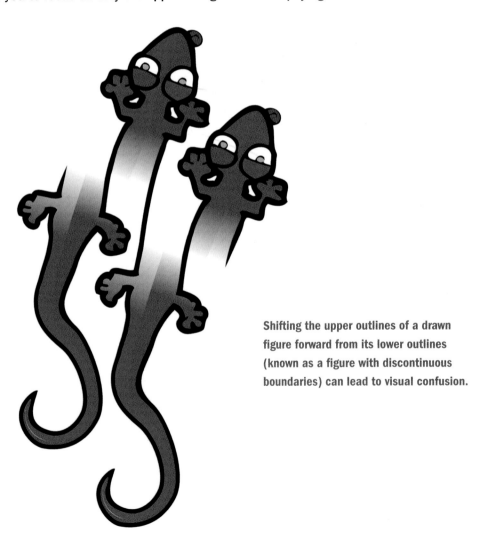

Shifting the upper outlines of a drawn figure forward from its lower outlines (known as a figure with discontinuous boundaries) can lead to visual confusion.

Figure/Ground Reversal

To create your first ambiguous figure involving a figure/ground perceptual reversal, first sketch a bulldog (Fig. 1) or any other breed of dog from a picture and then trace the outline of its main features with a pigment pen, a marker or even a brush (Fig. 2). You can use a lightbox for this purpose or, if you do not have one, simply place the paper against a window so that it is backlit.

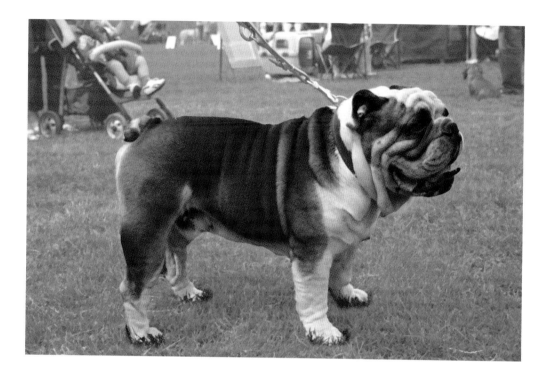

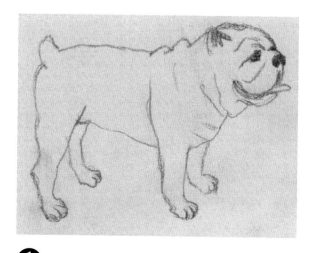

❶

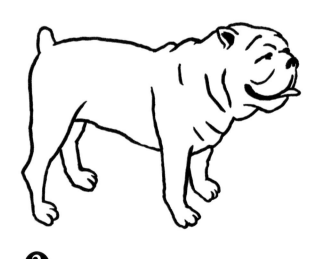

❷

At this point, cut the outline of the dog in half vertically and recompose the image by shifting a part of the dog until at least two lines of the composition meet in a straight line (Fig. 3). The final overall outline of the drawing should appear seamless, and you will use it as a pattern from which to make several variants. You can reproduce the motif by varying the direction and the number of repeats (Figs. 4a and b).

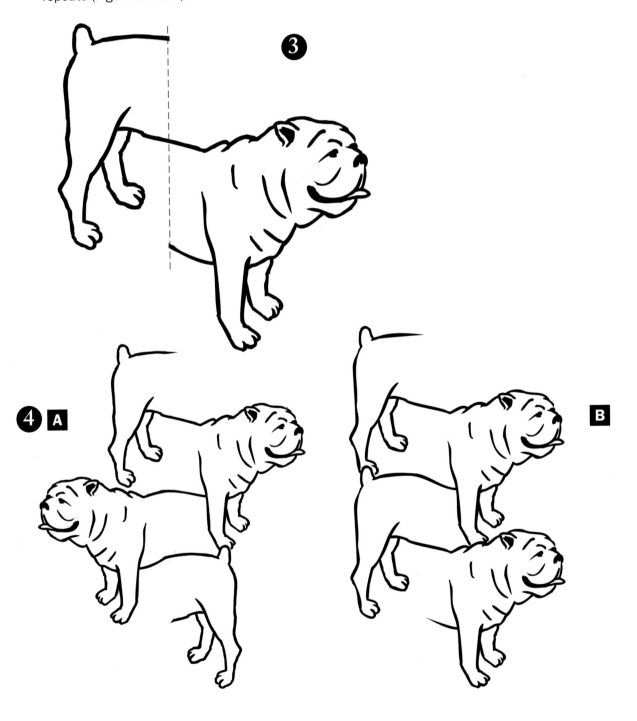

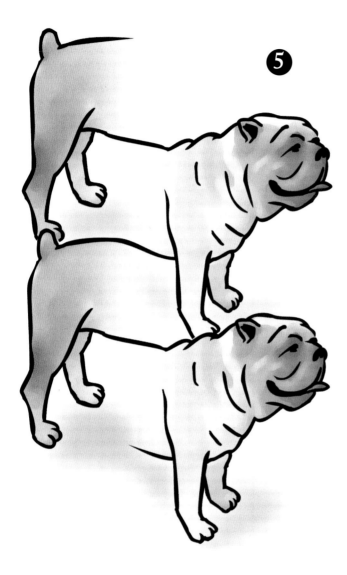

5

When you are satisfied with your drawing, colour it slightly to strengthen the illusion effect, using any medium and style you like (Fig. 5). For the version below I used watercolours, ink, then Photoshop for the negative image and reworking of colours (Fig. 6).

6

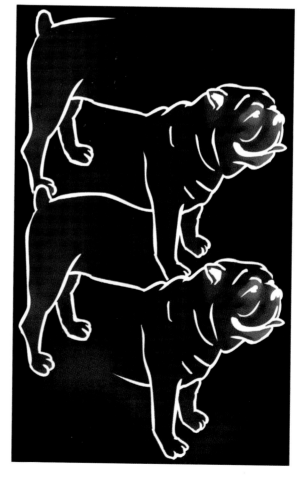

Undecidable Sailors

1 **A**

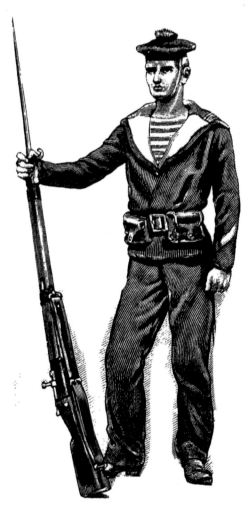

Make several photocopies of a vintage figure (preferably a picture of a standing man, woman or animal, see Fig. 1a). Then cut the figures out along their solid outer line, arrange them in a row and stick them all on to a white backing (Fig. 1b). You can see in the example that the space separating the legs and the rifles is uniform.

B

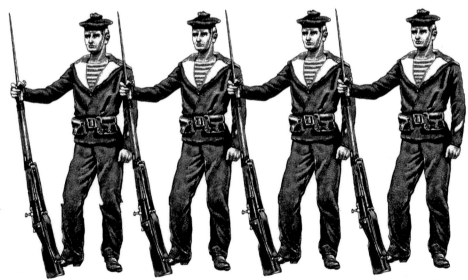

Now cut the collage in half horizontally and shift the upper outlines of the figures forward from the lower outlines, making the lower parts of the individuals' legs appear 'out of step' with their respective upper part (Fig. 1c). Make sure that the width of the blank spaces near the cut line coincides perfectly with the corresponding 'filled' spaces; you may use a pigment pen and correction fluid to adjust the gaps if needed.

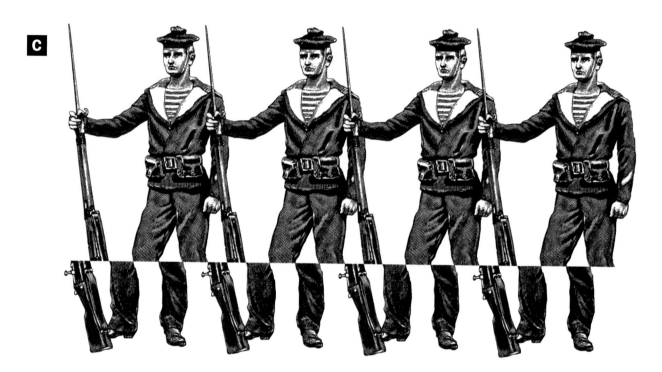

With the help of a hard eraser, shade the portions of the legs that border the cut line, and contain the row of figures within two extra elements that are not 'open': Fig. 1d shows a barrel and a solid rifle enclosing the sailors. The final touch is to delineate the outline of all the figures.

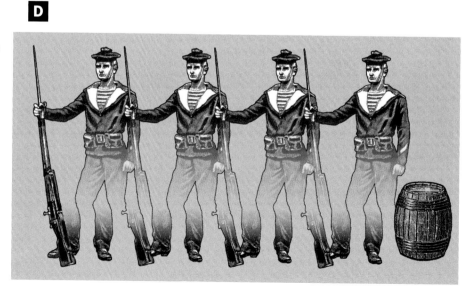

Using this picture as a model, you can apply a wide variety of art techniques and media to achieve remarkable visual results. Fig. 2a is a photocopy on to coloured paper, while Fig. 2b is made by applying an etching effect.

2 **A**

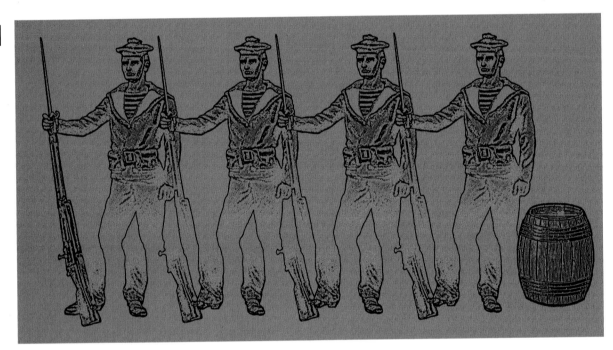

B

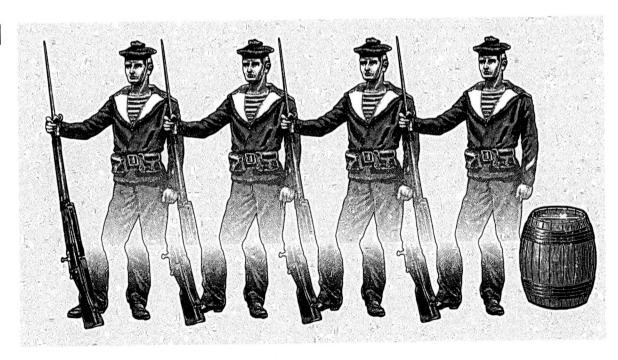

Negative Versus Positive

Here is an interesting variant of a figure/ground perceptual reversal which involves alternating black and white elements.

Draw two simple subjects such as two hands (Fig. 1). Then lay them together in a circular arc as shown in Fig. 2. Darken the arc-like shape and use this drawing as a model.

③

Then make five reproductions of the model and arrange them symmetrically in a linked circle (Fig 3).

Finally, fill the central blank of the design with black and then use your creativity and imagination to decorate this unused space. We are sure this example will inspire you!

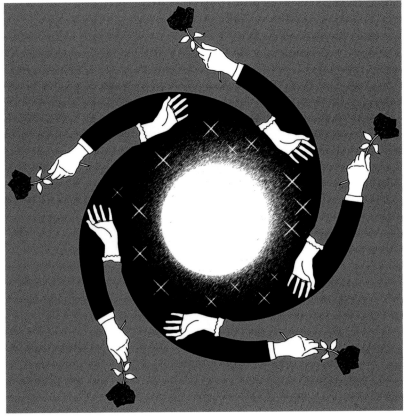

Encrypted Radiating Stripes

To create this kind of Op Art illusion you first have to select an iconic character such as Marilyn Monroe. You do not need a high-resolution reproduction to achieve the visual effect – what is important is that the picture has strong black and white contrasts.

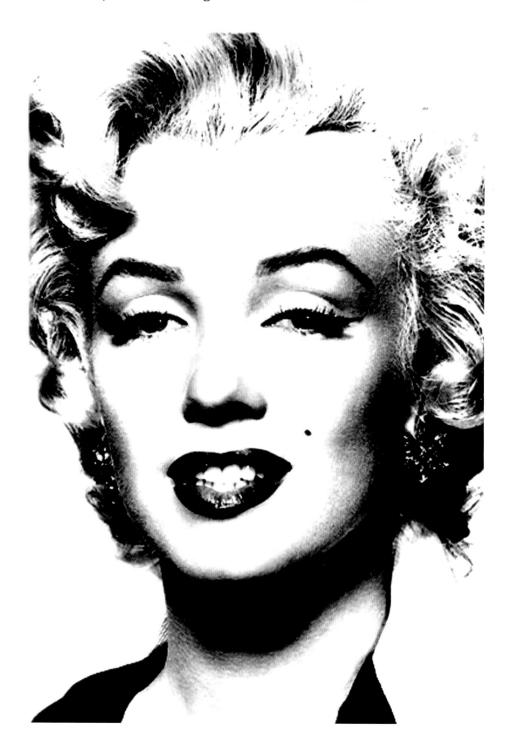

From a central point, slice the picture with two series of radial straight lines. In Fig. 1, you can see the starting set of two red rays enclosing two black rays. The two red rays are slightly larger and meet at an angle of 2 degrees, while the black rays meet at an angle of only 1 degree.

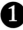

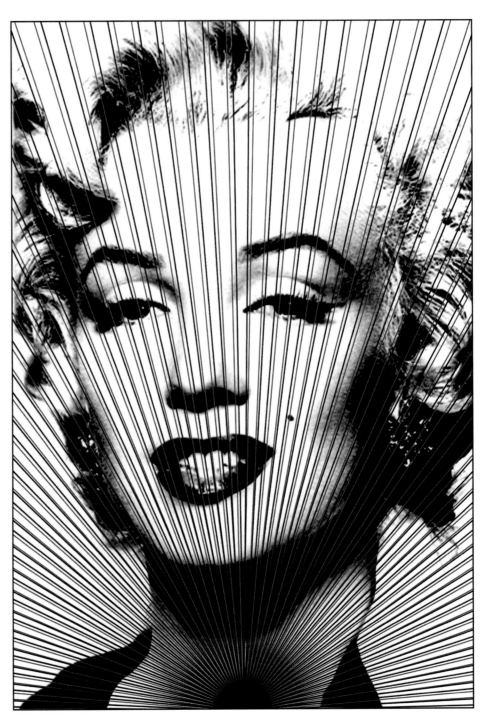

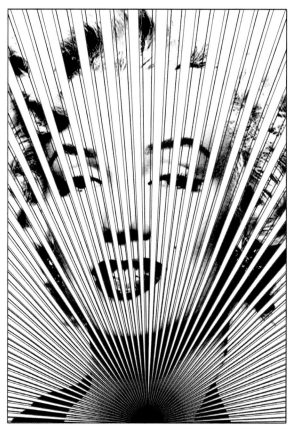

Now cut out the portions of the image that are enclosed between the red rays (Fig. 3). Alternatively, cancel them with correction fluid or white acrylic paint.

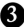

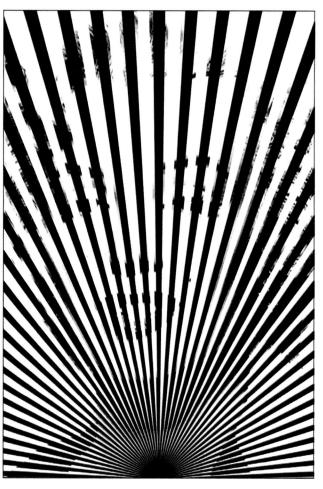

Then ink the portions of the image that are enclosed between the black rays (Fig. 4). Reproduce the image in black and white with the help of a photocopier or scanner and accentuate the rough edges of the black radial beams to give them maximum sharpness.

The final composition is a mysterious image made with quasi-uniform radiating stripes embedding a hidden portrait visible only from a distance (Fig. 5). To add colour, you can paint the black and white stripes with gouache or acrylic paint. Or you can scan the black and white model and use Photoshop to colour it (Fig. 6).

❺ **❻**

Zebra Intersection

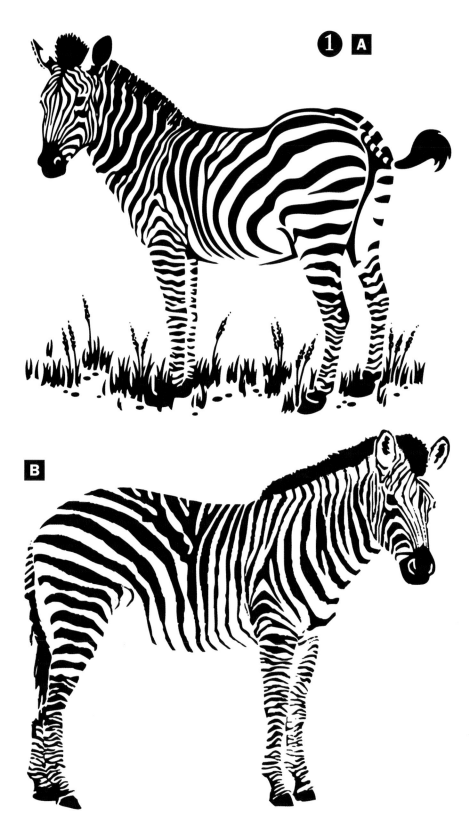

1 A

B

Here is another experiment with an optical illusion involving a hidden figure. This time, we shall be taking advantage of the striped coats of zebras.

First, photocopy two zebras from a picture or a Clip Art gallery – they should not look exactly alike (Figs. 1a and b).

Cut out the head of one of the zebras along its solid outer lines and place it within the breast of the other zebra (Fig. 2). Then accentuate the edges of the set of stripes that outline the zebra with a pigment pen to give maximum sharpness.

2

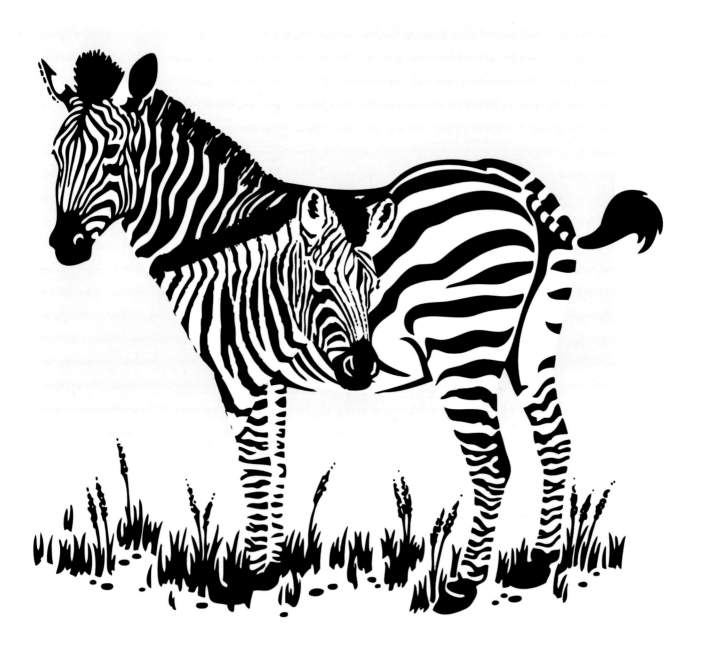

When you are satisfied with the black and white result, make several copies of it with a photocopier or scanner and add colour, experimenting with several mediums (Fig. 3).

3

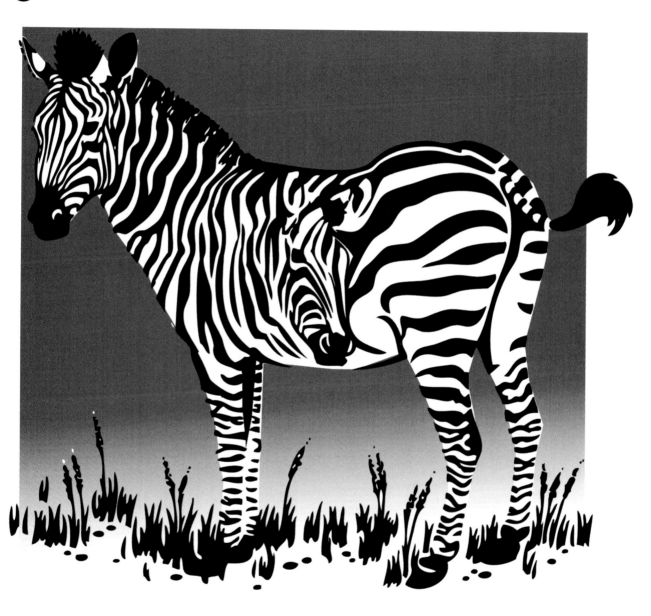